D1267133

BEYOND THE VISIBLE

SAYAKO ARAGAKI

gefen
publishing house בית הוצאה לאור
JERUSALEM ◆ NEW YORK

Third Edition 2007/5767

On front cover:
Details of the "Salon Agam" of the Elysee Palace reflected on Agam's sculpture
"Triangle Volant" placed in the center. The photo is courtesy of Mr.Philippe Migeat

Layout: Marzel A.S. — Jerusalem

ISBN 978-965-229-405-0

3 5 7 9 8 6 4

Gefen Publishing House Ltd. Gefen Books
6 Hatzvi St. 600 Broadway
Jerusalem 94386, Israel Lynbrook, NY 11563, USA
972–2–538–0247 1–516–593–1234
orders@gefenpublishing.com orders@gefenpublishing.com

www.israelbooks.com

Printed in Israel *Send for our free catalogue*

To the late Hideo Aragaki and Kimiko Aragaki

Acknowledgments

I wish to express my deep gratitude to my editors, Jean Stone and Janine Lanza. I would like to thank my publishers, Dror Greenfield and Ilan Greenfield of Gefen Publishing House for their support. My greatest thanks go to Yaacov Agam for his patience, his time and his help.

Sayako Aragaki
March 5, 1996
Jerusalem

TO YAACOV AGAM

Who renews without pause,

Breaks through new paths,

Discover hidden notions,

Intertwines taste and thought

Into an art of beauty and hope.

— Shimon Peres
President of The State of Israel

Translated by Stanley H. Barkan

© Gideon Lewin

Preface

Sayako Aragaki's book *Agam – Beyond the Visible* is a comprehensive and an easily readable study that excels by the precise descriptions of the artist's works and the simple, unassuming way his colourful life and complex theories are presented to the public. In this manner the tenor of Agam's numerous original statements is perfectly respected while their content becomes readily accessible to the general reader without losing its substance.

This book has the merit of trying to dissipate the confusion that exists in the mind of the public as regards the notions of Optical and Kinetic Art and it should help to establish, beyond any doubt, the historic role played by Agam as an originator and pioneer of the Kinetic Art trend in the early nineteen-fifties, a movement which generated a world wide shock wave in the area of contemporary visual art and which, for one reason or another, is still being overlooked and neglected to this day.

Two aspects are given special prominence in Sayako Aragaki's carefully composed book. The first of these aspects concerns the perceptible absence of a static image, a concept which is at the heart of the entire work of Agam and which corresponds to his desire to conform to the Bible's teaching and, especially, to the Second Commandment, which prohibits the idolatry of graven images. The second aspect relates to the subtle relationships that

exist between the Jewish and Japanese sensibilities and which find a special resonance here through the encounter of a dynamic Israeli artist with the sensitive Japanese author of this book which, in fact, was first written by her and published in Japan in the language of that country.

Agam's way to generate an image that lies beyond the visible is well known to mystics of all times: to conjure up the existence of the unknowable whole by its absence. After careful and repeated meditation on both the aesthetic and spiritual levels, Agam comes to the conclusion that 'reality' can be considered as the totality of simultaneous happenings and that in art, in aesthetic and spiritual thought, an indication of the entireness of reality could be envisaged. This knowledge and the feeling for the 'real' have been transformed by Agam into tangible propositions involving the concepts of time, movement and space.

Agam's spiritual stance resembles that of the *Kabbala* whose teaching sees the invisible in the visible, the spiritual in the corporeal, and the reflection of the unknowable God in everything.

Does such an attitude find its counterpart in Shintoist and Zen insights and sensibilities?

The incitation to go beyond the visible, the teaching that the important things in life cannot be weighed, measured or counted and that each new generation has its own special understanding of God and the world, as in Hebrew thought, has most certainly some affinity with the sentiment of power of all cosmic forces,

the impermanence of things, with intellectual detachment and with love of nature, as in Japanese sensibility.

In Sayako Aragaki's book the close relationship between the Jewish traditional and the Oriental religious outlooks have been perfectly perceived, as well as, more generally, the links between the artist's highly spiritual approach and his multidimensional production of more than forty years, ranging from polymorphic paintings, interactive art objects, transformable sculptures, video-art, computer-generated and holographic works to structures in multidirectional movement and continuous metamorphosis.

And this is, after all, the most essential part of this editorial endeavour: to allow an access, on the material, spiritual and aesthetic levels, to the richness of Agam's life production, to his secret personality, as well as to his art, whose key, it seems to me, is in his determination to transcend two types of opposition: on the one hand, between the individual and society through the involvement of the spectator who is expected to participate in the creative act, and, on the other, between spiritualism and rationalism or, indeed, between metaphysics and rational logic.

Frank Popper
Paris, February, 1996

Preface (2002)

Fifty years after Yaacov Agam's groundbreaking exhibition at the Craven gallery in Paris in October 1953, the historical dimension of that exhibition and its spiritual impact are now clearly discernible. Agam's artistic intuition and his works realized at that time played a major part in the evolution of the artistic climate and the discovery of new creative possibilities. Agam introduced through his art a new dimension — the fourth dimension, that of time and space.

This dimension compels us to change our attitude towards art and reality and the way to experience them. Since nobody can relive yesterday and nobody knows what will be tomorrow it is not surprising that Agam proposes that time be integrated into artistic expressions; that we can never see the whole in everything and that our vision should be focused beyond the visible and not on the immediately visible. This notion introduced by Agam in 1953 in contrast to the theories of abstract artists such as Kandinsky, Mondrian, Max Bill, or those of Agam's generation, should earn him a major place in the historical development of contemporary art.

Apart from his influence on the evolution of the visual expressions of the period, Agam extended the Fourth – the time dimension – into his large-scale architectural realizations. Examples include the monumental fountain at La Défense district in Paris, the Fire and Water Fountain in Tel-Aviv, his theatrical

multistage experiences as well as his interventions in many other fields, such as simultaneous writing that cannot be pronounced nor read but can nevertheless be perfectly understood, or his visual method of a non verbal language. The unity through the diversity of his creations emphasizes the scope of his prophetic artistic intuition. Agam has never failed in his artistic and spiritual endeavors to be faithful to himself and to the mission he assumed in the exploration of the artistic possibilities of the new dimension and the incorporation and use of new technologies into his research for the discovery of new options and new liberties. It must be said that Agam never fails to take part in the historical events of his time. Between creating a revolutionary environment for the Elysée Palace in Paris and producing a multidimensional art work for President Sadat of Egypt and Prime Minister Begin of Israel in order to promote peace in the Middle East, one could quote many other examples.

Agam incorporated his Dynamic Fourth dimension into his artistic practice and did not limit it only to his theoretical considerations. There is no doubt that Agam's approach inspired other contemporary artists now that the confusion between Optical and Kinetic Art is dispelled and the stature and historic importance of Agam has become quite clear.

Sayako Aragaki in the second edition of her book illustrates pertinently how the profound and many-sided, four-dimensional creations and ideas of Agam, elaborated in the intimacy of his studio, have become part of the new environment and of daily life all over the world.

Frank Popper
Paris, July 2002

Introduction for the Third Edition

Sayako Aragaki's book recalls in a concise and vibrant way the various stages of a work which, during the last half century, did not cease developing in many directions, while remaining faithful to the vision of the artist.

Considered in all its amplitude, it should be noted that the work of Agam is of an exceptional creative richness, that the artist himself has the spirit of a man of the Renaissance like Leonardo, that he succeeded in creating an in-depth alliance between art and science, art and technology, that he integrated his works in the urban environment and architecture, that he incorporated the natural and mobile forces like water and fire in his creative vision, that he created an educational project intended to transmit to the future generations a widened and deepened vision of the world.

The work of Agam is in permanent dialogue with the world of man and his environment, so that we can better become aware of ourselves, widen our visual and cognitive faculties, and look further into our relation with the world.

But the work of Agam is also there to provide us joy, to grant us again the innocence of the "Homo Ludens," so that its quivering colors and changeableness enable us to see the beauty of the universal cycles, as well as the inescapable flow of time. The work of Agam is a Utopia carried out daily. The artist invites us to discover the fifth and sixth dimension. And I do not doubt that it will open our eyes and senses to realities which, perhaps, we have a presentiment of, but are still unknown to us. Those will come to widen our imagination which is always with the mounting of essence, i.e. of the invisible one.

Marc Scheps
Former Director of the Tel Aviv Museum of Art and the Ludwig
Museum, Cologne

Table Of Contents

Prologue

THE BIRTH OF KINETIC ART

DEBUT

Yaacov Agam has made a major contribution to the history of art by introducing the notions of time and movement in art. With his creation of kinetic art, art which moves and changes, Agam made a breakthrough from the realm of the second and third dimensions toward the integration of the fourth dimension. He fundamentally challenged the accepted idea of art as a fixed image, and left a remarkable imprint on the art scene of the twentieth century.

Agam, then an unknown artist of 25, held his first one-man exhibition in Paris from October 30 to November 12, 1953. The show shocked art critics and public alike who were accustomed to traditional painting and sculpture, and who believed art to be a static medium whose objective was to immortalize life truths in a variety of fixed forms.

However, Agam executed his own work in a different dimension. His ground-breaking exhibition, consisting of forty-five works which sought to integrate the factor of time into painting, was the first to be *wholly* dedicated to art in movement. This exhibition brought the many faces of this new art to the wider public's attention. On display were *transformable paintings*, whose elements could be touched and turned and their positions changed in infinite configurations; *tactile paintings*, whose surfaces viewers could touch and alter by moving their components; *polymorph paintings*, reliefs made of countless numbers of triangular pillars, whose themes fused, disappeared, and reappeared according to the viewer's position. The works shown at this exhibition varied so widely that viewers could believe themselves to be at a group showing, rather than at an exhibition by a single artist. Agam created a *situation* which allowed the viewer to escape from the fixed and petrified image, and instead, to transform the works at will, to take part in the constant creation of his "original" work, through exercising the imagination. Further, Agam in his work created a fusion between the realm of art and his own Jewish identity, which made his creations strikingly original and expressive of a higher spiritual truth.

This first exhibition took place at the Galerie Craven, 5, rue des Beaux Arts, one of the most well-known galleries of contemporary art at that time. In 1953, Robert Lebel and his wife Nina introduced Agam to John Craven, director of the

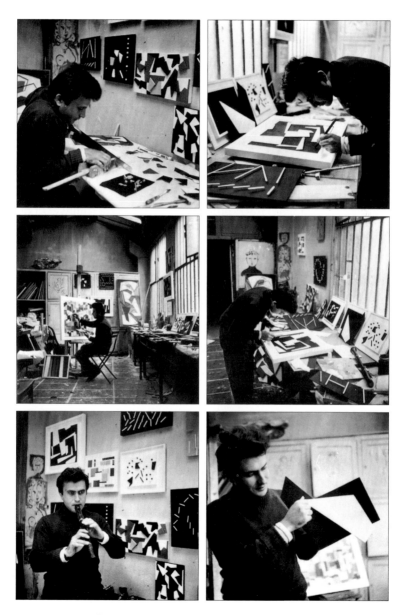

Agam in his studio in rue Béranger, Paris in the early 1950s

gallery. Craven had intended to hold the exhibition in the gallery's library, a relatively small space. But he altered his plans after a visit to Agam's atelier a few months prior to the show when he saw what Agam was creating. Craven offered Agam the whole gallery space, telling the artist, "Don't show your works to anybody, otherwise they may be copied. THIS show is going to be a BOMB!" Craven instructed Agam to create enough pieces to fill the entire main gallery. Hariett Nemenoff, a friend of his girlfriend, recalls that Agam worked hard day and night over a period of months in order to be ready for the exhibition.

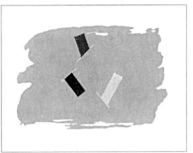

Invitation card for Agam's first one-man exhibition in 1953

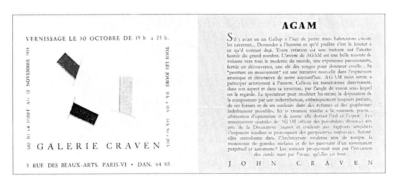

In 1953, Nemenoff was in Paris studying to be a concert pianist. In a recent interview, the auther was surprised by how vivid her memories remained, despite the passage of forty years. She described the preparations for the exhibition at Galerie Craven, and her chance involvement in this historic event. Agam did not want to send out the ordinary invitation for his exhibition, so, with Nemenoff's assistance, he created transformable ones, reflecting his style: at the center of a folded page, vivid red in color, were several slits which held pieces of different colored paper. When the invitation was opened, the added pieces popped up, creating a three-dimensional card. The recipient could also alter the position of these pieces. Thus the invitation card became a four-dimensional card. Craven approached a number of prominent art critics, asking them to write an introduction to the exhibition to be included in the invitation. These critics, hesitant to take risks and baffled both by the novelty of Agam's work, now known as kinetic art, as well as by their inability to connect it to what they considered established schools or forms of contemporary art, declined Craven's offer. (In the end, art historian Robert Lebel wrote the text. However, he did not sign it, so Craven did.)

Agam's exhibition, "Peintures en mouvement" ("Paintings in Movement"), held at the Galerie Craven in 1953, marked not only Agam's own sensational debut, but also was the first one-man show composed *entirely* as a *prise de conscience* (conscious act) of kinetic art. The paintings, which existed not

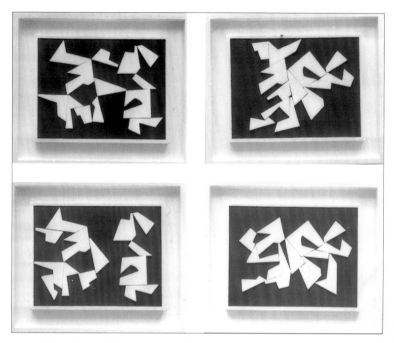

Transformable painting "White and Black on Black" (1953)
four different views

only in space but also in time, challenged human perception. The viewer was forced to realize that the surface image of the work which appears, disappears, and transforms made up only one part of the unified whole, all of which could never be seen at any given time. Agam's works urged the viewer to experience new visual phenomena, to *see beyond the visible*, and to participate actively in the creative *process* of the art itself.

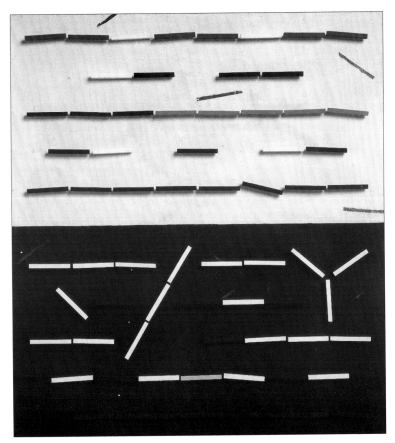

Transformable painting "Day, Night" (1953)

The significance of these innovations was manifest. Michel Seuphor, the first historian of abstract art, wrote in *Art d'Aujourd'hui* in August 1954: "Here is an artist of rare modesty: he does not impose upon the spectator his point of view but invites him into the game of choosing his own viewpoint." Seuphor was entirely correct to point out the

factor of play in Agam's work. Alain Jouffroy, a poet, wrote in *Le Journal des Beaux Arts* in 1956: "Agam has invented the painting in movement. This discovery gives new life to the too static and monotonous style-exercises of the painters of geometrical abstraction."

Agam's exhibition was followed by a spate of others featuring kinetic art. Pol Bury held his one-man show at the Galerie Apollo in Brussels in December 1953, showing his *plans mobiles* with a circulating moving surface. In May 1954, Jean Tinguely exhibited a number of reliefs which were activated by motors at the library of the Arnaud Gallery, in rue du Four, in the sixth arrondissement of Paris. Jesus Rafael Soto's superpositions of plexiglass and plaque were shown at the Salon des Réalités Nouvelles in Paris in 1954, where Agam

Agam with Nina Lebel (far left), at Galerie Furstenberg

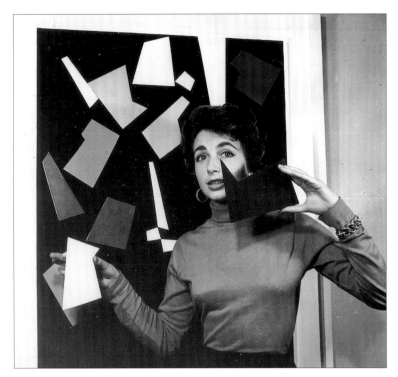

Transformable painting, "Movement and Transformation"
shown at the exhibition at Galerie Craven in 1953

also exhibited a transformable black-and-white painting and a large polymorph painting which metamorphosed as the viewer passed by. In 1955, a historic group exhibition entitled "Le Mouvement" was held at the Galerie Denise René, featuring Agam, Soto, Bury, Tinguely, Vasarely, Calder, Duchamps, Jacobsen and others.

Soon after Agam's show at the Galerie Craven in 1953, Nina Lebel introduced Agam to another gallery owner, Denise

René. In those days, her gallery showed exclusively non-figurative, hard-edged, two dimensional paintings and tri-dimensional sculptures. Denise René visited Agam's studio in rue Béranger and offered Agam a one-man show. Sometime after this proposal, however, Vasarely, who acted as an art adviser of the Galerie Denise René, visited Agam's studio and made another suggestion.[1] He persuaded Agam to "transform" his promised one-man exhibition into a group one, and urged him to "participate in" it. According to eminent French art critic Michel Ragon, abstract artists who saw and were surprised by Agam's success at Galerie Craven sought to use this exhibition as a means of reviving "kinetism": "Denise René proposed that he hold his second one-man exhibition at her gallery. However, this exhibition was to be substituted by Vasarely's proposition to exhibit as a group exhibition, with his manifesto, at the same gallery. Agam's art evidently seduced a few abstract artists, who wanted to take advantage of Agam's success in order to revive the forgotten kinetism."[2]

The young Agam finally made the concession and recast his one-man exhibition as a group one. In the end it included a group of young artists, namely, Agam (who displayed eighteen works), Bury (six works), Soto (who had just started to create works with movement, and displayed seven or eight) and Tinguely (who displayed six works). The works of these artists, which were art in movement, formed the core of the exhibition, but the exhibition also included several "big names": Marcel Duchamp (one work) and Alexander Calder

(two works of mobile art). Several artists attached to the Galerie Denise René also participated, such as Robert Jacobsen, with two sculptures, and Vasarely, with two works which were similar in style to Soto's work, but of two dimensional, optical art, which had no transformation. The imbalance in the number of works by each artist drives home the fact that this exhibition was originally conceived as a one-man exhibition of Agam's work. Agam, in his works, demonstrated the wide variety of possibilities of kinetic art in different media.

Vasarely, one of the oldest living artists participating in the exhibition "Le Mouvement," strongly supported by Denise René, put his own "Notes for a Manifesto" together with the essays of journalist-writer Roger Bordier, and Ponthus Hulten (who had never interviewed Agam, a major exhibitor, before writing his essay, and did not know his art), to create an essay for the exhibition. The major artists in this exhibition, such as Agam, Bury, Soto and Tinguely, had never been consulted on, or even heard about, this "Manifesto" until the day of the opening. They strongly protested against it. They were the core artists of the "art in movement" making up the exhibition, and they had much to say about kinetic art, but were deprived of the opportunity to create their own "manifestoes." This episode of the "Manifesto" resulted in confusion and misinformation, and gave the wrongful impression that Vasarely was both the most important theoretician of this genre of art as well as its creator. In addition, the writing mixed

up the new works of real kinetic art with optical art. Even today, many people still misunderstand. They believe that Vasarely (who only showed two pieces which were more representative of optical art than kinetic art since none of his work really changed structure) was the leader of the movement, or that the Galerie Denise René "created" the idea of paintings in movement. We can still see the evidence of this confusion and misunderstanding, for instance, in the catalogue of the exhibition "L'art en mouvement" held at the Fondation Maeght in the summer of 1992.[3]

Agam strongly opposed the original exhibition title "Cinétisme" (kinetism). He thought that while "movement" fit into a larger context, the idea of "kinetism" was rather limited. He was clearly thinking more about the factor of "time" in his work, and did not want to limit himself to the field of "kinetism." As a consequence, the exhibition took the title "Le Mouvement." Michel Ragon, in writing of Agam's work, stressed that "no one, before Agam, had had the idea to introduce real movement into a painting."[4] Ironically, according to Michel Ragon, "the exhibition 'Le Mouvement' held at the Galerie Denise René in 1955 was nevertheless considered as if it marked the birth of kinetic art. That, as we have already seen by now, was not the fact at all. However, its repercussion was considerable. In the history of kinetic art the exhibition marked the début of Vasarely, Soto, Pol Bury and Tinguely, and also worked as a reminder of antecedents such as Duchamp and Calder. There is no doubt (*however*) that,

without the impact of Agam's exhibition two years before, this particular exhibition would not have taken place."[5] So, this historical exhibition, now considered as the "proclamation of kinetic art," started under the title "Le Mouvement."

The exhibition proved to be a great success, imprinting the names of its young, creative artists such as Agam, Bury, Soto and Tinguely in the history of contemporary kinetic art. After this exhibition, many major museums and galleries of the first rank began to display works of kinetic art. It also launched a reevaluation of the works of artists of the preceding generation, such as Duchamp, Calder and Gabo. In fact, as Michel Ragon rightly pointed out in his essay "Pour une lecture polyphonique d'Agam" (which appeared in *Les Nouvelles Littéraires*, December 2-8, 1974), Gabo's experiments done in the 1920s had been forgotten, and while "kinetism was in the air, many artists had turned in the other direction. Agam seems to be the first one then to have exhibited the 'tableaux en mouvement' (paintings in movement) at the Galerie Craven, from October 30 to November 12, 1953)."

Furthermore, although Gabo (together with Pevsner) used the term "kinetic rhythms" in their *Realist Manifesto* in 1920, and Gabo's "Sculpture cinétique," made up of a steel wire attached to the base and vibrated by an electric motor, shown in 1920, has often been considered the first work of kinetic art,

in fact, it was not truly a product of a "prise de conscience," an act of consciousness, of the kinetic. For it is well known that Gabo never followed up on this experiment. He created static art works for the rest of his career.

The meaning of Agam's presentation in his 1953 one-man exhibition for the history of art is that he posed the questions of kinetism (which had long been forgotten and neglected), of movement, and, more importantly, of time, in varied and original ways. This meaning is based on Agam's firm belief that art which reflects reality should not be static, but rather should be expressed as a "situation" which is in a constant state of "becoming." This insight served as the source of his widely varying artistic researches.

Agam's works were exhibited widely following this path-breaking exhibit. A one-man exhibition was held at the Galerie Denise René in 1956 in which a variety of multi- dimensional paintings were shown. Another one-man exhibition was held in 1957 at the Galerie Aujourd'hui in the Palais des Beaux-Arts in Brussels. In 1956, he also participated in the Festival of Advanced Art in Marseilles, which took place in the famous Le Corbusier building, called Cité Radieuse.

Notes

1. When Vasarely met Agam for the first time in 1953, he declared to Agam, "I waited for a long time to see the young generation of artists arrive with a new proposition. We have no right to go back to the two-dimensional painting any more."

2.4.5. *Agam* by Michel Ragon, in the catalogue of the exhibition *Agam, Father of Kinetic Art*, Asahi Newspaper, 1989:

"Que montre Agam dans cette première exposition de 1953? Des tableaux mobiles formés de bâtonnets de bois placés sur un support et auxquels on peut donner la rotation désirée. Et aussi des tableaux superposés composés de reliefs formant différentes figures géométriques. Par là même, Agam s'insère dans la postérité du mouvement cinétique. Car le cinétisme est antérieur à Agam, mais il avait été totalement oublié. En 1920, Gabo exposait en effet une tige d'acier mise en mouvement par un moteur qu'il appelait "sculpture cinétique" et, entre les deux guerres mondiales, le cinétisme était bien connu des peintres et des sculpteurs d'avant-garde, notamment de Moholy-Nagy, Fernand Léger, Duchamp et Calder.

Toutefois, personne, avant Agam, avait eu l'idée d'introduire le mouvement réel dans un tableau. Mais plus que le cinétisme, ce qui intéressait Agam en 1953, c'est la transformation interne du tableau et la participation du spectateur invité à déplacer à son gré les bâtonnets pour construire le tableau de son choix.

Bien qu'accueilli avec chaleur par les surréalistes, c'est néanmoins du côté de l'abstraction géométrique que se tournera Agam qui expose, dès 1954, au Salon des Réalités Nouvelles et auquel Denise René propose une seconde exposition personnelle dans sa galerie. Toutefois, celle-ci sera repoussée en raison de la proposition de Vasarely d'exposer en groupe et avec un manifeste dans la même galerie. L'art de Agam a en effet séduit quelques artistes abstraits qui veulent profiter du succès de Agam pour ressusciter le cinétisme oublié. Agam, qui ne se considère pas comme un artiste cinétique, refusera néanmoins que soit repris ce terme pour l'exposition collective qui portera celui de Mouvement. L'exposition *Le Mouvement*, Galerie Denise René, en 1955, est néanmoins considérée comme l'acte de naissance du cinétisme. On a vu plus haut qu'il n'en est rien. Son retentissement sera néanmoins considérable. Elle marquera les débuts, dans l'histoire du cinétisme, de Vasarely, de Soto, de Pol Bury, de Tinguely et un rappel des antécédents de Duchamp et de Calder. Sans aucun doute, sans l'impact de l'exposition de Agam deux ans plus tôt, elle n'aurait pas eu lieu."

3. We can often find a confusion of two different types of art: *Optical art* (or, as it is often called in a shortened term, Op art) which depends on an effect of optical illusion, and which is in the second dimension, thus static, with *kinetic art* which contains the factors of movement and time, thus incorporating the third and the fourth dimensions. This confusion was accelerated by some exhibitions by commercial galleries, notably by Galerie Denise René, putting these two different kinds of art under one flag. This already happened from the early stage of the kinetic art, that is, since an exhibition "Le mouvement." Galerie Denise René constantly displayed the two-dimensional works of Vasarely and other artists of optical art in the context of kinetic art. For a long time she tried to enhance Vasarely's work by giving it a "kinetic flavor" to make it more appealing. Also, she would often hand people a yellow-colored leaflet of the exhibition "Le mouvement" which includes Vasarely's "Notes for a Manifesto," and that became another misleading source that has been creating confusion till now. (In fact, even in the mid-nineties, this leaflet is still reprinted by the gallery and given the public and media.)

MAX ERNST, THE FIRST COLLECTOR

The artists and poets of the Surrealist movement were the first to recognize the importance of Agam's work. "It was Max Ernst who first bought my work in my first exhibition," recalls Agam. The piece was called "Signes pour un langage" (Signs for a language). (Years later in 1989, Agam bought it back from Ernst's widow, Dorothea Tanning. Later, Dominique Bozo, then the Director of the Visual Arts at the French Ministry of

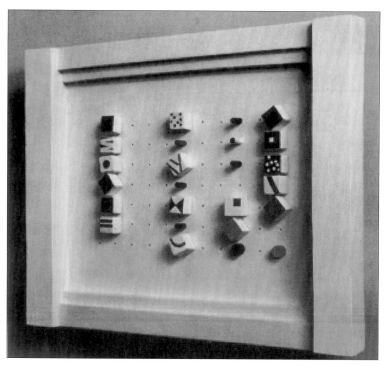

Transformable painting "Sign for a language" (1953)

Agam with Jean Arp

Culture, acquired the work together with several other pieces by Agam from the same period for the collection of the National Center of Contemporary Art (C.N.A.C.). The piece is now to be found in the Grenoble Museum). Jean Arp, a painter, sculptor and poet, also bought Agam's work. André Breton, a leading figure in the Surrealist movement, was greatly moved by one of Agam's transformable paintings; he named it the "Dybbuk," saying that the way the viewer arranged the pieces could reveal the depths of his own heart. He considered Agam a kindred spirit. Breton wrote about one of Agam's works: "A transformable painting such as I have never seen before.... It was an old engraving which, seen from the front, revealed a

tiger. But as it was covered with slight vertical scratches placed at right angles to the surface, when seen from the left, the painting revealed a vase. And when seen from the right, it revealed an angel." (Breton was writing of these figures symbolically, for creatures, either animal or angels, are never actually represented in Agam's works.)

After Ernst acquired one of Agam's transformable paintings, they had other occasions to know each other better. The two artists established a friendly relationship. Agam visited Ernest's studio, and his home as well which was the top floor of a building overlooking the Seine. Ernst lived there with his wife Dorothea Tanning, an American painter. An exhibition of "Fantastic Art Dada Surrealism," held in 1936 at the Museum of Modern Art in New York (in which Ernst showed forty-eight works), opened her eyes to Surrealism. Since that time she painted fantastic works with the theme of sexual obsession. She married Ernst in 1946.

The year Ernst saw Agam's exhibition, 1953, was the year of Ernest's final return to Europe. As persecution started in 1939 in France, first by the French authorities for being an "enemy alien," and then by the German Gestapo, Ernst left Europe in 1941 for the United States. He arrived in New York on the Fourth of July, and two years later met Tanning in Arizona for the first time. Although his first journey back to Europe after World War II was in 1950, and his first comprehensive exhibition in Germany (actually in his home

Transformable painting "Dybbuk"

Karel Apel with "Dybbuk"

town of Brühl) in 1951, it was in 1953 that he finally made up his mind to move to France – to live and work there.

"When I first went to his place, I was flattered, because I found my painting 'Signes pour un langage' on his work table," said Agam smiling. "I was fascinated by his playful work method which succeeded so naturally. It was like an improvisation. While sketching, he would discover something stimulating, and would promptly catch up and work on it."

More striking were the occasions when Ernst came to Agam's studio to work with him. In those days, aside from his creative work, Agam was earning a living by making silkscreen prints for gallery exhibition posters and printing illustrated poetry booklets for artist-poets. (For instance, he printed Jean-Jacques Lebel's first booklet "Chose.") At that time, Ernst was not too familiar with the technique of this printing medium (silkscreen), so he came to visit Agam's studio in rue Bélanger to learn and try it out for himself. They worked together for a few days, Ernst experimenting with Agam on his system of silkscreen, such as duplicating forms in symmetry and in assymetry. "Together we made some hundred eighty pages of silkscreen monotypes and prints. I enjoyed it very much. It was like this: some of the pages were done partly by Ernst and partly by myself – as he did structure, I put in colors, or, as I made forms, he put in colors. Or, he did this page while I did that page. Interesting in this work together was that it was full of fascinating structures," said Agam.

Sometime after he left Agam's studio, Ernst called him, saying that he wanted to keep half of those works. So, together they divided the pages equally: Each kept works by both artists. "Did you ask him to sign on the pages that he made?" asked the author when interviewing him for this book. The answer was "No, I didn't care." The young artist was naïve, or was just more interested in the fascinating structures on those pages.

Sometime later, Ernst held an exhibition of his recent works in a small gallery in Paris (Galerie Loeb on rue de Rennes). Agam visited the show to discover, to his pleasant surprise, that approximately half of the exhibit consisted of the pages which were done together with Agam in his studio. Most of those pages were experiments and monotype.

One day Agam passed Edward Loeb's gallery in Paris. When Loeb learned about the pages done in Agam's studio, he eagerly persuaded Agam to entrust the unsigned pages now in Agam's collection, to him. He said he would have Ernst sign them for Agam. Agam's wife told him not to give them to the gallery owner. However, after Loeb gave Agam a letter in which he undertook to return the pages to Agam, the latter agreed. Sometime later, when Agam asked Loeb what happened to those pages, Loeb said that he never got them back from Ernst.

To make a long story short, Agam never got them back. He shrugged sadly, saying "It is a pity, because those forms were so interesting. I never saw them again since then."

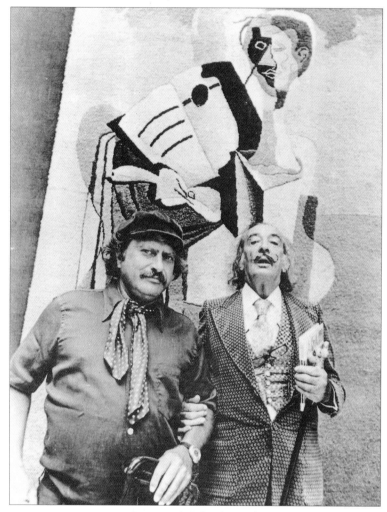

Agam with Salvador Dali

Other figures in the Surrealist movement took an interest in Agam's art. A well-known collector and patron of the movement, Vicomtess de Nouille, was enthusiastic about his

works and bought a number of them. Agam was introduced by Robert and Nina Lebel to the Surrealists' circle. Robert Lebel was an art expert who wrote a great deal about Surrealism. In this way, Agam became acquainted with artists such as Salvador Dali, Roberto Matta and Wilfredo Lam, and was seen more frequently at the Surrealist circle than at the Atelier d'Art Abstrait of Dewasne and Pillet at the Académie de la Grande Chaumière, in which he had enrolled.

It is interesting to note that it was Surrealist artists, rather than art critics, art historians or the general public, who appreciated the significance of Agam's work in its earliest stage. Perhaps this was to be expected. It is not surprising that the Surrealists, who proclaimed the liberation of imagination, who were anti-rationalist in their thinking, and sought a true expression of thought, should have understood Agam's work which challenged and overturned the accepted notion of art as a fixed image and, indeed, went beyond the visible.

THE EARLY YEARS

IN THE PROMISED LAND

Yaacov Agam was born to an orthodox Jewish family in 1928. His father, Rabbi Yehoshua Gipstein, was a rabbi in Rishon LeZion, a small village in what was then the British Mandate of Palestine. Rishon LeZion is now a town of moderate size, located south of Tel Aviv, with a population of approximately 175,000. In the 1930s, however, it was a small place; you had only to walk for a few minutes and you were out of the village and amongst sand dunes.

Rabbi Yehoshua was strictly orthodox and scholarly in his approach to religion, having written a number of books on Jewish spiritual and religious themes. Yehoshua's father-in-law, Pombrofsky, a wealthy merchant, was proud to marry his daughter, Kendel, the youngest and most beloved of his eighteen children, to so learned and religious a young man. He provided the couple with financial assistance to enable

Yehoshua Gipstein to continue his Torah studies. This tradition, in which a father-in-law would undertake to support his son-in-law's studies, was well-established in pre-World War II Jewish society in Europe. Shortly after their marriage, the young couple were almost on their way from Poland to the United States, where he was offered a position as a rabbi in a city near Chicago. However, he changed his mind and chose to emigrate to Palestine, the "Promised Land" of the Jewish People.

In Palestine, Rabbi Yehoshua devoted his life to the study of the Torah, to meditation and to his writings on religious matters and philosophy of Judaism, especially on Kabbalah. He also served as a rabbi in Rishon LeZion, acting as a consultant to the villagers, and serving as an arbitrator on religious and civil matters as well. Yaacov Agam remembers his father either writing at his desk or praying in the synagogue and fasting. "My father fasted twice a week, on Mondays and Thursdays, according to Jewish religious tradition," recalls Agam. "He was a spiritualist who tried to dissociate the body from the spirit."

Naturally, Rabbi Yehoshua cared little about material matters. The family was soon reduced to poverty. Looking back on those hard days, Agam wonders how they managed to survive. In spite of the difficulties, however, Rabbi Yehoshua was the mainstay of the family – before, and even after his death. "My father passed away on a Friday evening," recalls

Agam. "As he stepped into the synagogue, he suddenly fell and departed without suffering for the other world." To die inside a synagogue at sunset on a Friday is a rare occurrence, and religious people believe that it is the way God calls His faithful; therefore, such an ending to life is granted only to the *tzaddik* (righteous man).

His father's absorption in the study of the mystical Kabbalah and search for the invisible, hidden Divinity influenced Agam powerfully. It is no coincidence that Agam as an artist, a son of such a father, conscious of his father's quest, should have directed his research toward the "reality beyond the visible" in the field of art. "Perhaps I am a visual rabbi," smiled Agam shyly, indicating that he does secretly see himself

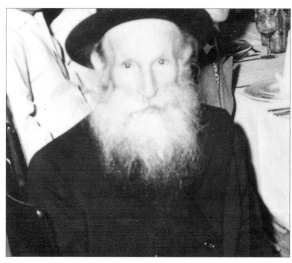

Agam's father, Rabbi Yehoshua

as a spiritual inheritor of Rabbi Yehoshua. Agam carries on the tradition in his own distinctive way. In Judaism, a monotheistic religion, the individual confronts God directly, face to face. Just as what we pray for is unique and original, and differs from one person to another, so there are infinite possibilities for the interpretation and understanding of the Torah. Therefore, Agam has his own form of prayer, saying "I don't pray with words. I pray *visually*. My works are, so to speak, a visual prayer."

Agam's childhood was a lonely one. Although he had started to attend kindergarten, he did so for only a few days. "Kindergarten was located at some distance, so the kids had to be taken there and picked up by the parents. But nobody in my family bothered to take me there," said Agam. "My father was always busy in the synagogue, and in a big family you could easily get lost." (Agam was the seventh child of nine brothers and sisters.) When he reached school age, Rabbi Yehoshua did not want to send his son to a secular elementary school, and there was no cheder (religious school for boys) in the small village of Rishon LeZion. "Actually there was a huge public school located right in front of our house. You just had to cross Herzl Street, a major artery, but again I could not enroll in the school!" said he. "From the house terrace I watched children going to school and I envied them."

A couple of years later, when a cheder was established in Rishon LeZion, he finally enrolled. "But, you know, I already

knew the taste of liberty, so I could not stand going to the same class and to see the same people day after day," said Agam, smiling. "So, I dropped out of school." Finally a private tutor was hired to teach him. He was an old man, a "melamed," who offered mainly religious instruction.

Later, when Yaacov was a young teenager, his elder brother Bezalel took him to Tel Aviv to look for a school that might suit him. As the father almost always kept himself busy in a

Young Agam in Rishon LeZion (c. 1942)

synagogue or in meditation or in writing a commentary on Kabbalah, the eldest son naturally tried to take responsibility for family matters. When they arrived in Tel Aviv, Bezalel looked around the city, trying to find a school for his brother. At last he saw a school building; they went in and he registered his brother. "What a primitive way to find a school for a boy!" said Agam, reflecting on those days. It was called the Pitman School, and was rather a business-oriented school where students acquired, in addition to the general courses of studies, typewriting, shorthand and bookkeeping skills. Agam attended the school for a year. "The majority of my classmates were girls, but one of my male classmates later became a famous judge in Israel," said Agam.

At about the same time, Agam tried to enroll in Avni's Art School in Tel Aviv, which was then the only school for art in the area. (Avni was a known Israeli painter in those days.) He brought along his paintings to his interview with the director of the school. However, Agam was refused entry as he did not have enough money to pay the tuition. Years later, Agam, now a well-known artist, met Avni on an occasion of his one-man exhibition in Paris in the late 1950s. He asked him if he recalled refusing Agam a place in his school. "Why didn't you tell me at the time that you were a genius? We would have been honored to take you," replied Avni with a smile. Agam makes light of his early "education". "The first degree I received was an Honorary Doctorate from Tel Aviv University in 1975," he

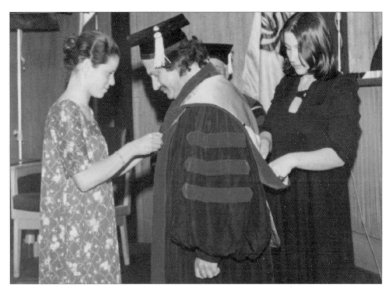

Agam receiving Honorary Doctorate from Tel Aviv University (1975)

says smiling. Had Agam been "properly" educated, however, the question arises whether he would have become an artist and been capable of producing the art he ultimately went on to create.

Later, in 1945, his family decided that the Bezalel Academy of Art in Jerusalem would be the right choice for Yaacov. His father took him to Jerusalem for an interview with the director. "You cannot imagine what a big trip it looked like to a young boy. In those days, going from the small village of Rishon LeZion to Jerusalem was like an adventure," reflected Agam. It was somewhat dangerous because it was a long, narrow, winding road between steep cliffs in a mountainous area,

passing by many Arab villages. The impact of the city of Jerusalem on a young boy was immense. It was like going abroad, the mixture of cosmopolitan people, peoples of different religions (while most of the residents of Rishon LeZion were Jewish), the buildings made of Jerusalem stone, a multitude of decorations of the holy places of different religions, the landscape of the city, and, particularly, the feel of this city. Agam tells an episode about his father at that time: "When we happened to come across a procession of Christian pilgrims in Jerusalem, my father, being a religious man, covered his eyes with his hands in order not to confront the Christian cross." There Agam first met Mordecai Ardon, a famous painter, who was then a director of the Bezalel Academy. Agam was accepted by the Academy, and started a new life in Jerusalem.

At the beginning of his Bezalel years, he lived in a small room in Bet Hakerem, a western suburb of Jerusalem. Later he moved to the city of Jerusalem. To earn his living, Agam worked hard every weekday night until dawn in a laboratory, mostly enlarging photographs. From there he went straight to the Bezalel Academy. In those days, when he arrived early from the photo lab, he would often meet at the stairs of the Academy his school friend, Avigdor Arikha, who is now a well-known painter. "He was a survivor of the Holocaust, and arrived from Europe in a group of 'Youth Immigration' in Israel. Arikha used to live in a kibbutz in the suburb of Jerusalem called Kiryat

Anavim, and would arrive at the school very early as he often used the delivery service of kibbutz products to the city. That's how we met every morning at such an early hour," reflected Agam. Later, they met each other, quite unexpectedly, in Italy in 1950, and then in Paris in 1951.

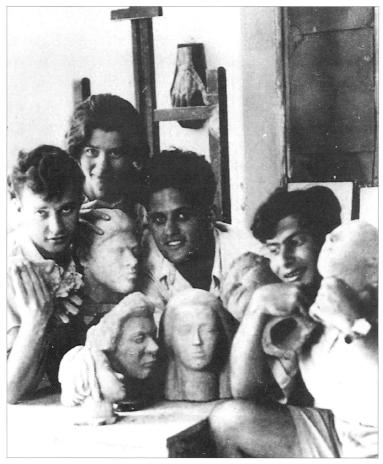

The young Agam as a student of the Bezalel Academy (right), (1946)

After his week of hard work it took him the weekend to recuperate. Every Friday afternoon he would go back home to Rishon LeZion by public bus, and on Saturday he would rest almost all day. "Going back and forth from the valley (Rishon LeZion) to the mountain (Jerusalem), I never got bored, because the road never seemed the same to me. Even today, there is a magic going up to Jerusalem. In those days, the sky, the clouds, the color of the landscape, and the feel of it was new to me every time. It was changing all the time. So different from the route from Rishon LeZion to Tel Aviv which was always the same and lacked that thrill," reflects Agam.

The hardship of living, however, weakened the young man's health. One day, he went to a concert by the pianist Pnina Zaltzman. It took place in the beautiful amphitheater of the Hebrew University of Jerusalem campus on the hill overlooking the Jordan Valley and the Dead Sea. Having no money to purchase a ticket, he climbed a fence, when, all of a sudden, he was bitten by a bee. He got a blood infection so easily, because he was so weak, and he had to stay in bed for two weeks.

Mordecai Ardon told Agam the philosophy of the Bezalel Academy according to its founder Boris Shatz: "An artist must get a profession which has a connection with his artistic activity, in order to secure his existence and his daily bread." So, Agam also studied graphics, lettering, printing, etc., all of

which later was helpful in the difficult years in Paris before his work became known.

Agam received his education from self-study and the environment rather than from the classroom. The streets around him were filled with people from all around the world: Jews from Yemen, Germany, Poland, Russia and Egypt, united in Palestine, but still holding on to their traditional cultures and languages, fostered in their places of temporary residence in the Diaspora. Only in certain Jewish communities was Hebrew spoken. Arabs, dressed differently according to their clans and their occupations, British soldiers and policemen, as well as public officials, walked the same streets. Agam enjoyed roaming through the dunes and the desert. There he observed the Bedouins and learned their traditions, their behavior, and Arabic. The neighbors were shocked by Agam's free ways and warned his parents, saying, "Nothing good will come from this boy!" Agam himself looks back at those days and says: "In fact, when I was a kid, I was behaving differently from other kids, spending a lot of time out on the dunes, and sometimes even doing things such as picking up unexploded bombs left by the British army after military exercises in the dunes. I dismantled them and played with the explosive powder." From an early age he had a passion to experiment and invent.

A person generally acquires language through communication with others. Agam was different in this respect, too. Alone for much of his childhood, his dialogue was

with himself and took place in a silent, visual language. He was always drawing. "My first 'canvas' was of the moving sand of the dunes," says Agam, "The image I drew on the sand was instantly transformed into another shape by the blowing wind. The image appeared, then disappeared within seconds." Agam never tired of this scenery. In a sense, he had an unconscious fascination with "kinetic art" from the days of his youth. The creatures living in the desert were also a rich source of inspiration to the young Agam, with their mysteries of metamorphosis: "A caterpillar encloses itself in a cocoon, cutting off its contact with the world completely, and then one day a beautiful butterfly emerges from the shell. It bears eggs...thus the cycle goes on." In this fascination with the richness and mystery of God's creation, with its transformative capacities, the influence of the mysticism of the Kabbalah can be glimpsed. The wonder of nature was an open book for Agam to learn through his visual experience.

What, then, drove Agam to become an artist? We can probably guess at a reply by asking: What was the first occasion when he was exposed to art, and what sort of art impressed him so much...

For many years Agam's eldest brother, Bezalel, subscribed to "Gazit," a magazine on literature, art, theater, etc. It showed many illustrations of fine art. In those days Rishon LeZion was a small village and there was almost nothing which you could name as cultural or artistic. This magazine became, in a way,

a window to the world of art for a small boy of five or six, and Agam spent a lot of time looking at this magazine. For example, it was there that he discovered the works of Honoré Daumier. "I admired his satire as 'another reality' exaggerated in a certain situation," reflected Agam. There was also coverage of Jewish artists such as Chaim Soutin, which impressed him. "For years I read the magazine. It kept up my curiosity and interest in art," says Agam. Years later, Agam happened to meet the editor of the magazine, who later published an extensive article about the Agam Exhibition held at the Tel Aviv Museum in 1958.

At the age of twelve, he encountered a book which became one of the greatest influences in his life. It was "Lust for Life," a book about Vincent Van Gogh by Irving Stone. When it was published in 1934, the book attracted a great response. Van Gogh's struggle to create art much impressed the young boy. A good friend of Agam, named Luther, whose parents had immigrated to Israel from Germany, was also a great admirer of Van Gogh: he dressed like him, went out in the countryside and painted in his style. He and young Agam were immersed in a sort of total human experience about Van Gogh. They not only read the book about the artist, they tried to "experience" Van Gogh's dramatic artistic adventure. This influenced Agam greatly; he practically lived for some time in the shadow of Van Gogh.

At this time an episode involving his father gave him an intriguing hint about the relationship between Judaism and

visual art. At first Agam was very afraid of his father's reaction toward his drawings, as drawing a figure or an image is strictly forbidden, on religious grounds. (Recall the Second Commandment, "You shall not make for yourself a graven image.") One day, however, the Rabbi told his son a story: When he was a student at a yeshiva (religious school), he made a drawing on a handkerchief and forgot it on his desk. Afraid that the rabbi would punish him for transgression, he hurried back to school to look for it, but in vain. Sometime later, when he had already forgotten about it, he found, to his great surprise, the very drawing hanging on the wall of the rabbi's house...

"From then on I became interested in the relationship between Judaism and visual art," said Agam. The critical questions then arose: Is Judaism really against art? Are Jewish people really not allowed to make art? Or, is it only against *a certain type of art*...? This was perhaps the beginning of a lifelong research.

As a teenager, Agam lived for a few months on Kibbutz Yad Mordekhay. This kibbutz, located not far from Ashqelon, is quite well known: Founded in 1943, it was named in memory of Mordekhay Anilevitz, leader of the Jewish revolt against the Nazis in the Warsaw Ghetto. At the beginning of the Israeli War of Independence, in May 1948, the isolated kibbutz was attacked by the Egyptian army. After severe battles, a siege, and months of occupation by the Egyptians, it was liberated

and a new kibbutz was built, becoming a symbol of heroism reborn.

It was impossible to live in Palestine in the 1930s and 1940s and be unaffected by the politics of the region. The area has functioned as a crossroads between civilizations and cultures for thousands of years, and therefore has a distinctly charged atmosphere. In 1945, Agam was detained by the British authorities without being charged or sentenced. Hundreds of young Jews in Palestine were similarly detained. It was part of an attempt by the British to prevent the immigration of Jews from Europe to Palestine, Jews who had desperately fled from the hands of the Nazis, and to forestall the involvement of Jewish youth (which had resulted from this British interference with immigration) in underground

Agam at Kibbutz Yad Mordekhay (front at far right) (c. 1944)

movements seeking to put an end to the British control of Palestine. These movements were working toward the establishment of the independent State of Israel. Agam's older brother was the leader of one such underground group. At the time of his arrest, Agam was only seventeen years old. He was placed in a prison in Jaffa and then in Latrun, located between Tel Aviv and Jerusalem, a detention camp of sorts for members of the Jewish resistance. There were dangers associated with imprisonment: In the Jaffa jail, young prisoners could be attacked by hardened criminals who were serving life sentences and had nothing to lose. (For this reason they always went to the toilet in groups.) In Latrun the British indulged in their own forms of *sophisticated nuisance*, such as turning off the water to the showers while prisoners were covered in soap. Also, as the British decided to expel some of the detainees to Africa, many refused to disclose their identity for fear of being deported. However, the British devised a plan: they announced that free cigarettes and gifts would be given, and names were called out. When the prisoners realized it was a British trap, it was too late. In the middle of the night, hundreds of paratroopers invaded the camp and picked up these people to be sent to other concentration camps in Africa, where some died.

Agam was fortunate in that his elder sister, Bruria, brought him food packages from time to time. She had to walk many miles off the main road leading to Jerusalem on rainy days or

Agam's drawing done in the British detention camp in Latrun (1945)

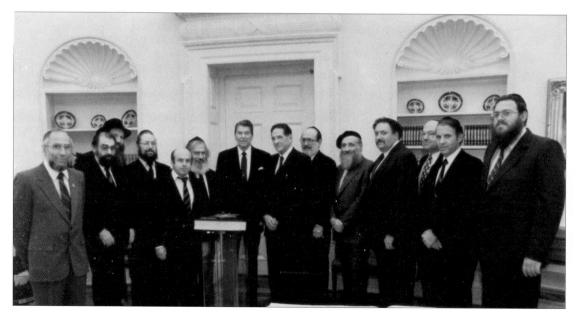

Agam, Nathan Scharansky and Jewish leaders at the White House with President Reagan (1988)

under a blazing sun, and had to wait for long hours at the gate under the hostile eyes of the British authorities, until she could find someone who would volunteer to deliver the package to her brother.

His imprisonment, however, had a positive aspect. It provided Agam with a first-class education, for being held in the detention camp were political offenders who were later to become the founders and leaders of the State of Israel.

Agam drew profusely during this period. It was a surprise to him to see his fellow detainees, traumatized by the hardships of prison life and by the persecutions of the British authorities, become engrossed in drawing and painting. Although many of them had never been exposed to art, when Agam started to help them become familiar with artistic experience, using small pieces of wood and paper, they were practically unconscious of the time they spent devoting themselves to these activities. This experience also opened Agam's eyes to the power this artistic experience had on people. He held the conviction that the involvement in the visual art is almost a "necessity" to the human beings.

One of Agam's sketches done in the detention camp is of a young prisoner lying on a bed. He later used this sketch on a New Year's greeting card for the year 1948, the year Israel declared its independence. He inscribed on the card the words: "For a Happy New Year of Freedom and Independence."

The sketch on the greeting card reminded the author of an episode which occurred years later. In 1988, Agam, together with Nathan Scharansky and other Russian Jews, was invited to a ceremony held at the White House by a group of people who had supported those Jewish *Refuseniks*. (Refuseniks are the people who sought to leave the Soviet Union but were not permitted to do so, and were often harshly persecuted by the Soviet authorities. For instance, Scharansky was arrested just after his marriage and was imprisoned for many years, becoming the symbolic leader of the Refuseniks.) They presented President Ronald Reagan with Agam's Haggadah. On that occasion Agam told the President, "In the Jewish tradition, the only books which were artistically illustrated are the Haggadah and the Megila, and both of them are the story of the people struggling for liberty. That is why this book of Haggadah is presented to you, because you helped those people in Russia seeking freedom."

GOING TO EUROPE

In 1951 Yaacov Agam went to Paris for the first time. He was twenty-three years old. "For me, going from the small village of Rishon LeZion to Paris was comparable to going to the Moon," said Agam. Although he had been studying at the Bezalel Academy of Arts and Design in Jerusalem since 1946, he had found the experience of limited value because of the

school's almost exclusive focus on technique. His teacher there, Mordecai Ardon, a former student of the Bauhaus in Weimar, encouraged his young artists-to-be to travel to Europe.

Unable to speak French and without any financial means, Agam worked quietly in his "studio" near the Place de la République in Paris. It was a kind of small back-room with an open ceiling only partly covered, made available to him, as a remuneration for his small services, by a local Jewish organization. He ate lunch occasionally in a Jewish soup kitchen together with the poor and elderly. For the evening meal, he used a can which he picked up on the street to warm up a soup over a candle. He also picked up boxes and crates from Les Halles, the central market of Paris, to use for his art work. Agam had planned to stay in Paris for only a very short time, since he was on his way to Chicago, where he was to continue his studies and activities at the Illinois Institute of Technology. Paris, however, captivated the young artist-to-be.

Before arriving in Paris, Agam travelled around Europe. In 1950, he toured much of Italy, visiting the museums, churches and historical sites of Naples, Pompeii, Rome, Florence, Venice, and Milan, and some villages. He was constantly taking notes, making studies and thinking about the things he saw. In Padua, Giotto attracted him, while in Verona, the mosaics were a source of much interest. This great heritage of beauty and art, however, presented the young artist of the 1950s with a

difficult question: If this was the art of the past, what should characterize the art of our own time?

Agam spent some time living in Zurich. Through Mordecai Ardon, Agam was introduced to Johannes Itten (Ardon's former teacher at the Bauhaus) in 1950. Itten, a Swiss, had been invited to Bauhaus in Weimar in 1919. He had developed Herzel's theory of colors, and had established a system of basic art education. He was recognizable by his shaven head and strange monk-like costume. With Itten, who was teaching at the Kunstgewerbeschule, Agam studied the elementary aspects of form and color and, at the same time, became familiar with the spirit of the Bauhaus.

While in Switzerland, Agam also met Max Bill, an architect, painter, sculptor, and theoretician, and the two became friendly. Bill was a student of Vasily Kandinsky at the Bauhaus in Dessau. He developed the clear concrete constructive theory which could be used as a base for plastic art, thereby making a contribution to the development of non-figurative art. Bill became famous for his sculptures and paintings which used pure color and form – the language of artistic concrete expression.

The environment was a stimulating and exciting one for Agam. Nevertheless he had his own questions and found they could not be answered satisfactorily by those around him: "All these works of art, the researches and theories were done in

the realm of the second and third dimensions. The fourth dimension did not even enter their minds," says Agam. Agam had been seeking something beyond static art but could find little guidance from those he met. However, he had a strong feeling, akin to intuition, that there should be another form of art which will express this particular realm.

Around this time, Agam attended the classes of Siegfried Giedion at the Eidgenössische Technische Hochschule and at the Zurich University. Giedion was a well-known writer and historian, whose books such as *Space, Time and Architecture* and *Civilization toward Mechanization* were received as

Agam with Max Bill and Arthuro Schwartz in his Paris studio
(c. 1979)

authoritative sources by designers, architects and theoreticians of the plastic arts of the 1950s, and at the same time had a great impact on the general public as well. Agam, too, was deeply impressed with Giedion's ideas on the notion of time. Giedion had been a student of the historian Jacob Burkhardt (who developed the field of art history) and was the General Secretary of the International Association of Architects. Through Giedion, Agam was privileged to be introduced to architectural luminaries such as Frank Lloyd Wright and Le Corbusier. Zurich of the post-World War I years served as artistic center for the Dada movement which started in 1916, and when Agam arrived there, it still kept a memory of the movement and was somehow an active place for artistic creativity and experimentation, particularly in the area of concrete art. We also should not overlook the fact that many intellectuals and artists who fled from the oppression of Nazi Germany sought refuge in Switzerland from the late 1930s to the end of the World War II. Therefore, in the 1950s there still remained an atmosphere of intellectual inspiration which attracted people to Zurich.

As an assistant to Giedion, Agam was able to participate in a number of seminars at the Eidgenössische Technische Hochschule. He learned of Massul's theory of the pyramids of ancient Egypt and studied Greek, Roman, Italian, Baroque and modern design and architectural concepts. Agam also developed an interest in the history of the evolution of musical

forms. Most exciting, however, was what he learned about the prehistoric period. The mural paintings of this epoch provide the first evidence of human artistic expression, coming, as they do, long before the creation of idols. "A certain sense of 'expectation' could be perceived in these paintings," explains Agam. Agam visited a number of prehistoric caves, such as Lascaux in southern France and Altamira in Spain, and wrote case studies for the book Giedion was producing at the time, *Eternal Presence*. "I still have many of the sketches I made in those days," says Agam, taking out some old, faded notebooks.

Agam describes his thoughts in relation to the drawings in the ancient caves: "People draw on a wall only those objects that are important to them, or they create pictorial embodiments of their prayers, expectations, wishes. What was the greatest concern of the people of ancient days?" Agam asks. "It was the procurement of food and survival. If you look at the mural paintings in the caves, you will not see images of beautiful women or birds, not even wild animals such as lions, tigers, etc. Mostly you will see oxen, mammoths or cattle. These symbolize food – the key to life and survival."

Agam continues: "At a later stage, we begin to see sculptures of feminine figures. These are mother goddesses, with big breasts and bellies, who symbolize fertility. Their facial details were not depicted. Next we find images of kings and forefathers. By this stage, men have faced their fate, that they

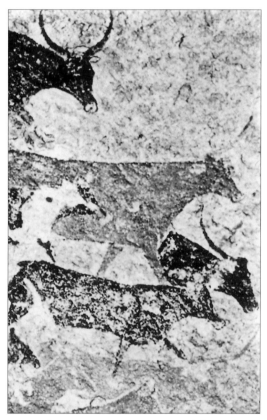

Wall painting in a cave – one of the earliest
paintings by human beings

are mortal, and thus try to defy 'time,' which eventually brings with it death and the loss of everything they know and have. They seek to construct something that will overcome death, such as the building of monuments in ancient Egypt." Looking at these images, the young Agam realized that all art, modern and ancient, neglected the factor of "Time." In other words,

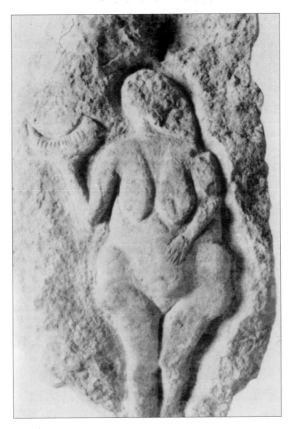

Mother Goddess, symbolizing fertility

art consisted of a static report of what had happened in the past. It was this early discovery which has become the foundation of his research, and led Agam toward kinetic art.

Thus, in these early experiences, the seeds of Agam's later artistic research were sown. The years spent in Switzerland

In Egyptian relief, Pharaoh's statue is drawn much larger than the people

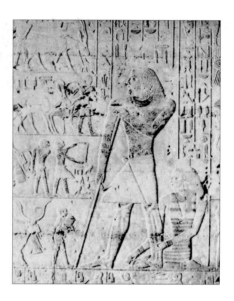

and Italy were crucial, since his eyes were opened to the basic idea (concept) of his artistic creation which started in the 1950s. For the style of his plastic art, which is itself a transformable one, is based on the *firm belief* that was cultivated in those days. And, although he had been fascinated with the yet unarticulated notion of fourth dimensional art even before his departure for Europe, it was those formative years of the early 1950s that transformed a "supposition" into a "firm belief."

It must also be remembered that throughout the Europe of the 1940s and 1950s, debates were raging about different aspects of abstract art. Agam's sensational debut in 1953 must be seen in the context of this controversial atmosphere. All of a sudden, here was a young artist whose viewpoint was

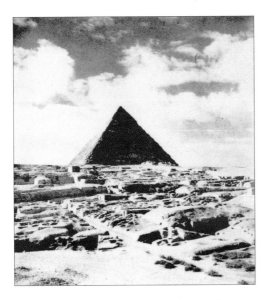

Pyramid, a monument to defy "time" to all eternity

at a completely different stage from the heated discussion of his contemporaries. Agam avoided the presence of the image itself, presenting instead a *situation* "beyond the image," and thereby introducing into art the factors of "movement" and thus of "time." Little wonder that Max Ernst rushed to take up his work.

BRANCUSI, OR A CREATIVE OBSESSION

In the early 1950s, Agam made the acquaintance of the sculptor Constantin Brancusi. Brancusi was born in Romania and had lived in Paris since 1904. Under the influence of August Rodin, Brancusi bid farewell to academicism and

created sculptures which were reduced to the pure effect of material, volume, and rhythm. Agam visited Brancusi's atelier-dwelling space in Paris. It was a minimalistic space, characterized by pure simplicity and lack of decoration – the house of a monk. This studio has been preserved intact in the Centre Georges Pompidou in Paris.

"Brancusi was a person who cared only about the essence of things, in life and in his art," says Agam. "It is astonishing that the basic and original thoughts Brancusi managed to express with simple words often carried a universal meaning. For example, Brancusi would say, 'Although no two people in the world are the same, doctors use the same medicine for each person. Why?'" Questions such as these stayed with Agam for a long time. They had a profound effect on him when he created art which would metamorphose and, while communicating to all, would look different to each person, thus becoming each viewer's "original image," and which still contains a universal meaning. Of course, Agam as an artist-to-be had been harboring for some time already, like an obsession, the themes, such as an artistic expression of the fourth dimension and the omnipresence of the Hebraic God Who is beyond the visible, which worked as the basic nuclei of his creation. However, when it came to an actual plastic expression, Brancusi's simple but suggestive words resonated deeply within the young Agam and gave him confidence.

Brancusi himself was obsessed with an idea linked to the revival of the Biblical flood and the resulting destruction of the world. Sensing imminent destruction, Brancusi dreamt of creating an eternal art piece that would be buried deep within the earth. Following the next flood, it would be unearthed by survivors. Despite the fantastical elements of this vision of deluge, it functioned as a form of reality for the great sculptor and explains his preoccupation with survival and destruction.

Agam was influenced in three ways by this vision. First, it led him to turn to the rainbow, the symbol of the post-flood covenant between man and God (he often uses the colors of the rainbow in his work). Second, unlike Brancusi who wished to create a subterranean monument, Agam worked toward allowing audiences enjoyment of the present and the progressive nature of time through their participation. Thirdly, while Brancusi consciously worked with timeless material such as marble and stone, the material of Agam's art was the "element of time."

YVES KLEIN

When Agam arrived in Paris in 1951, the first friend he made was Yves Klein. They met one afternoon in the Café Dome in Montparnasse. "Yves was very friendly," recalls Agam. "In

those days I knew only a few words of French, so we started the conversation in a mixture of English and French. He liked provocative conversation, and I enjoyed it very much every time we met. In a way we stimulated each other. You see, we were in the same kind of situation: We were not known. We were just starting. We were seeking and searching for a sort of 'base' for our own art." In many discussions he had with Agam at that time, Klein expressed his anti-conformism, anti-culture, anti-painting opinions, which went strongly against the accepted ideas of society, and he soon became obsessed and desperate to run away from all "imposed limitations." He told Agam many times that he wished he could "reach another planet" where the order of life and values would be different. As a matter of fact, both of Klein's parents were painters, and it seems likely that this state of mind could originate from such a family situation.

Soon after, Klein suddenly declared to Agam that he was leaving for China – a place indeed as far and as different in culture as a young French man could hope for. It was, however, difficult to visit communist China in those days, so Klein started off living in Japan, hoping to cross from there to China. Unable to obtain a visa, Klein settled in Tokyo, where he learned judo. He returned to France a few years later and made his living as a judo teacher in Paris. It was around that time that Agam met Klein again.

Even though he was rebelling against the situation he was in, Klein was deeply in the milieu of the artistic circle. In those days, artists and critics met weekly in the evening on the ground floor of a café called Place Clichy. Michel Seuphor, a historian of abstract art, was a leading figure in this circle, and also Jean Arp was frequently seen there. There they would show each other catalogs of their exhibitions and discuss their activities. Klein accompanied one of his artist parents on such evenings, but having no paintings or catalogs to show, he felt uncomfortable and excluded. One evening, Klein brought along a hand-made booklet which was filled with pieces of colored paper, rectangular in shape and pasted down. Instead of the text of a poem, a few black lines were traced. "Look what I have done. This is my catalog," proclaimed Klein. Some of the artists thought it amusing and, knowing that Klein had produced it as a joke, asked him where they could obtain copies. In response, Klein printed a few hundred copies of the booklet which some people bought for fun. His friends then asked him, "Where are the 'original' paintings of these flat one-color paper cuts?", knowing full well that they did not exist. Klein then painted the "originals" and in reply to the question "where are they being displayed," Klein sought a place to display his works.

At that time, there was an annual exhibition at the Musée d'Art Moderne de la Ville de Paris entitled "Salon des Realités Nouvelles," dedicated to abstract art. Established artists and

members were invited to exhibit their work. Young and unknown artists were able to present their works to a selection jury a few days before the opening. If approved, their works would be included in the exhibition. The president of the jury at the time was Auguste Herbin, himself a famous abstract artist, known for his use of squares, triangles and distinctively-combined colors. When Yves Klein presented his painting of a single color, Herbin saw it as a simple provocation and rejected it. Klein protested and demanded to know the reason, and Herbin replied: "A painting must have at least two different colors." Klein felt victimized and misunderstood, and announced to everybody he met, "I am a victim! I was refused! I am not understood!"

Colette Allendy ran a small avant-garde gallery in Paris and, in order to "do justice" to him, she agreed to exhibit Klein's single-colored work refused by Herbin, together with other works similar in that they were also single-colored works of red, blue, chrome, and so on. At the opening of the exhibition, Agam said to Klein: "Yves, if you regard the wall as one big canvas, the effect of what you create is not so unusual: a mural of many colors. I think you should paint *all* the paintings in the same color." At this Klein became furious.

Nevertheless, some time later Agam was invited to another of Klein's exhibitions. Agam entered and was surprised to see that all the paintings were painted in the same color, later to be known as "International Klein's Blue."

Klein needed time to select and absorb the ideas and suggestions offered to him by others, so that they would become really "his own ideas." For Agam, to observe this phenomenon of Klein was extremely captivating. Agam would put forward proposals which Yves Klein would initially reject and oppose, aggressively at times. Eventually, however, Klein would absorb and adopt the ideas as his own way, and actively promote them. Agam vividly recalls that one morning Klein came to his studio in rue Béranger near Montparnasse, and brought with him a canvas on which he tried to attach gold leaves in order to create a gold monochrome painting. He explained that there was a problem since the glued leaves did not stick evenly to the surface, and were moving around at the edges like flags in the wind. Klein considered Agam a good technician and asked him how he might glue the leaves on to the canvas so that they would stick to the surface evenly like gold paint. But Agam replied, "Please, Yves, leave it as it is, or even make it looser! Then when people come close to view the painting all the gold leaves will move, and you will have a kinetic gold art work!" Agam recalls that "Yves got mad at my comment, and left my studio in a fury. Some time after, I visited a gallery that showed Yves' works, and was surprised to see the large gold surface painted with gold leaves. When the spectators approached, the leaves 'mysteriously' started to move, as they are so light that the slightest air caused by the breath of the viewers can put them into vibrating movement." Yves Klein recognized Agam's contribution to this

phenomenon, and called to offer him the first gold-leaf painting as a gift. Agam did not care about the painting at the time and did not go to pick it up, in spite of Klein's constant calls. Several months later, "Yves called me and 'threatened' that if I didn't come to pick up his gold painting, he was going to sell it to a German art collector. At that time I was so busy with my own work, I did not come, and Yves sold the painting."

Agam continues: "A year later, when I visited Yves' studio, he reminded me that he was sorry he sold the painting, but at the same time he reproached me, saying that I hadn't cared to pick up the painting which he offered me as 'a part of my contribution to his work' and as a friendly gesture."

On his part, Agam had very little time, since he devoted most of his time to the absorbing, labor-intensive, elaborated art works he was creating at that time. As a consequence, he was fascinated by Yves Klein's ability to generate media coverage of his work. For example, Klein got special permission (not easily obtained) from the post office to send mail using his own newly-created stamp. The stamps contained no writing: all that could be seen was a patch of "Klein blue." Klein sent out thousands of invitations to the opening of his show at the Galerie Iris Clair. However, the gallery was so small that only a dozen people could fit into it at the same time.

On the occasion of another of Klein's exhibits, all the roads around the gallery were blocked off. Police cars and fire engines

rushed into the area. The next day Yves Klein's show was the talk of the town. The media wrote about the incident, people gossiped about it, and as a result everyone came to know the name of the artist. It turned out later that all the excitement was the result of a phone call Yves Klein himself had made to the fire department!

One day at Agam's studio, Klein parodied the enormous amount of time Agam invested in every work, sometimes months and even years on one painting (such as polymorphic painting with triangle-relief surface, which is time-consuming). Klein explained that "even if the work you have created after such an effort is a very important creation and has a very significant universal message, and if it is sold to an art collector, he will put it in his home and only very few people would know about your creation, however good and ingenious and extraordinary your work might be." Klein continued, "I prefer to spend less time on the art work and more time on making it known." He was not joking, but, on the contrary, firmly believed in it, because he thought that his idea and his concept would live longer even after his actual art work is gone.

Agam told the author one episode: "On one of Yves's visits to my studio, I told Yves that I can make 'his painting' (his 'Klein blue') as only a small part of my painting – as one of the views in my polymorph. I built up the structure (in the painting) which goes slowly from the very basic simple situation which then evolves to more complex images with

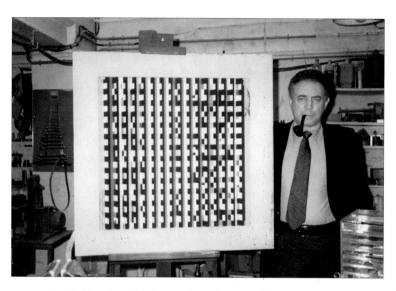

*Bill Rubin of the Museum of Modern Art at Agam's atelier
with "Monochrome Blue and Color Rhythm Polymorph"*

many colors and to the polymorphic orchestration which
absorbs everything – color, shape, and rhythm – in a
symphonic fusion, thus creating a feeling of space. The celestial
blue of the sky is so powerful and shiny that you practically
cannot see any stars or the moon shining, but when you go
out of the blue, suddenly all the things which are in the blue
would appear. So, I told him that, like this, you can get a much
more profound experience." That is to say, in this painting,
from one extreme side, the viewer can see only monochrome
blue; from the other extreme side, one can see the stripes of
blue and white; and from the countless numbers of angles in
between, one can see the rich variation of rainbow colors, but
the blue is present here and there, as a reminder. Agam spent

over a year on this polymorph painting. This painting, "Monochrome Blue and Color Rhythm Polymorph" is now in the collection of the Museum of Modern Art in New York. (While a curator of the museum named Bill Rubin liked the painting and chose it for the collection of the museum, when he heard this story he told Agam he liked it even more.)

Agam and Yves Klein also participated together in a show called "L'Objet" at the Musée National des Arts Décoratifs at the Palais du Louvre in March, 1962. Agam showed a model of his multi-stage theater project, while Klein exhibited a model of his environmental project. In this project, the system could change the weather by creating an enormous air ceiling where clouds could be dissipated by the air pressure coming out from bottles, which children loved to empty over and over. Klein was obliged to refill the bottles continuously, a task which exhausted him. Klein complained that the popular newspaper "Combat," which featured a good arts page, mentioned Agam's theater model exhibit but did not discuss Klein's project. The omission especially upset Klein since his project required so much energy. Agam remembers Klein complaining of fatigue at that time, a fatigue which would later prove to be fatal.

Yves Klein died of a heart attack on June 6, 1962, at the early age of 34. Agam met Klein just a few hours before his death. The two had coffee together at the Café Select in Montparnasse. Klein was complaining again of fatigue, and

said he was thinking of driving to Nice to spend a few days recuperating. Agam could not imagine that he would receive a phone call at 4:00 p.m., just a few hours after their meeting, from a mutual friend who told him that Yves Klein had passed away. At that moment Agam suspected for a second that perhaps the funeral was another of Klein's publicity stunts. "When people attend his funeral, Yves might jump out of the coffin," thought Agam. However, the terrible news was true, and Agam was shocked to lose such a close friend so suddenly.

Klein's early death made him into a legend. Pierre Restany, in writing of Yves Klein and his work, contributed to the making of this legend.

SCHÖFFER AND MALINA

Nicholas Schöffer had been exhibiting at the Galerie Denise René in the 1950s, but did not participate in the exhibition "Le Mouvement" in 1955. At that point in time, although interested in cybernetics and movement in art, he had not yet created any works which featured real movement. A year and a half after "Le Mouvement," Schöffer was exhibiting as a part of a group at Galerie Denise René. During a conversation with Schöffer, Agam approached one of Schöffer's rigid sculptures, which was placed near the corner of two walls and was illuminated from below by two light projectors. Agam moved

the lights a little further away from the work, and proceeded to rotate the sculpture. "Look, Schöffer," Agam called out, "look at the shadow on the wall, running in all directions! It's more interesting, more unexpected. This is more challenging, there is more life in the work like this." Schöffer protested strongly. "He was furious. His anger was such that I remember it vividly to this day," says Agam.

Why did Agam do this? In those early days of kinetic art, Agam felt he had a mission to convince people of the importance of movement in art. He sought to "convert" people to the movement of movement.

About three months after this encounter with Schöffer, Agam attended the exhibition "Art menage," held at the Grand Palais. (The exhibition took place every year, but in 1958 it happened to be held at the Grand Palais which was a very prestigious forum.) In the main hall, Agam saw a big wall (about 30 feet long and 18 feet high) on which were being projected light and shadows, running in many different directions. Intrigued, Agam approached the wall and peeped behind to see what was creating the effect. There he found Schöffer's sculpture. Schöffer had elected to show only the moving light and shadow created by the projector and rotating sculpture, rather than the sculpture itself. This was later to become emblematic of his style.

Another artist to "convert to kinetism" was the American scientist and artist, F.J. Malina, known also as the founder of the art and science magazine, "Leonardo." Malina had an interesting life. Originally from Texas, he had spent a few years in Czechoslovakia in his youth. He then had a successful career working as a rocket scientist, supervising the construction of a high altitude rocket, and was the director of an international committee which investigated the establishment of a scientific laboratory on the moon. Malina ran his own company which carried out experiments in rocket technology. The company was commissioned by NASA to do a great deal of work, and Malina became a wealthy man. Later in life, he settled in Paris and as an art lover began to create his own works. He used scientific symbolism in his paintings and then shifted toward using three-dimensional aspects in his pieces.

Agam and Malina were introduced by a mutual friend shortly after Agam's exhibition at Galerie Craven in 1953. They met several times and had long discussions in which Agam attempted to persuade Malina of the importance of time and movement in art. Malina was opposed to Agam's ideas, insisting that art be figurative and static. In those days, Malina was creating figurative paintings with a Surrealist slant. Later, however, he began to use artificial light, and then introduced an electro-mechanical system called "Lumidyne" for which he became well known. Malina grew to be devoted to the idea of art in movement, developing his personal artistic sensitivity

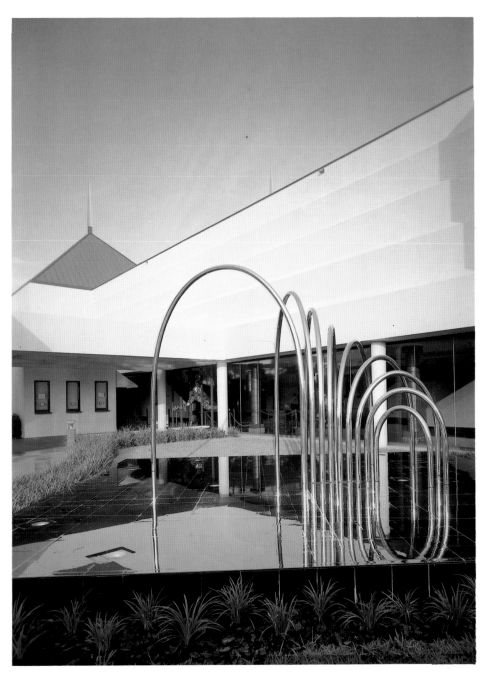

"Gateway to the Arts" at the Philharmonic Center
for the Arts Naples, Florida (1995)

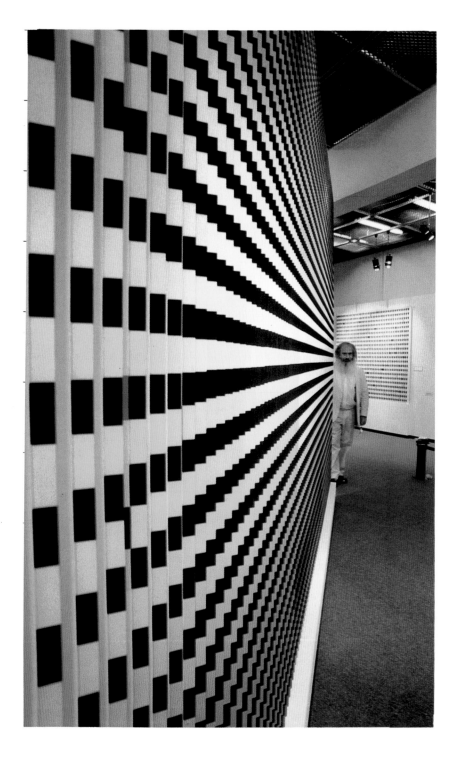

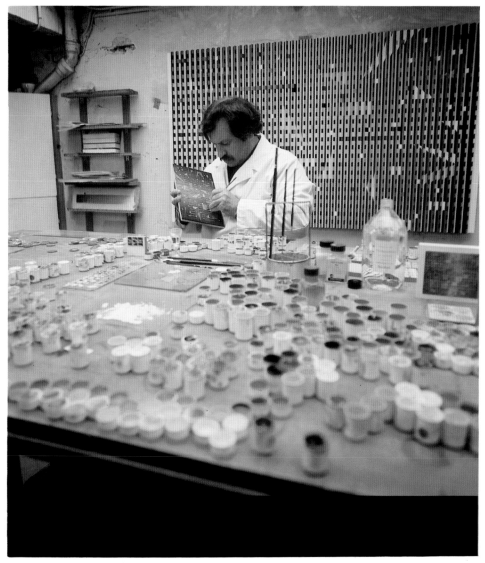

Agam in his atelier in Paris (1967)

Opposite Page:
"Transparent Rhythms II" (1967-68, collection of the Hirshhorn Museum and Sculpture Garden, the Smithsonian Institution), picture taken at the Agam retrospective exhibition in Tokyo (1989)

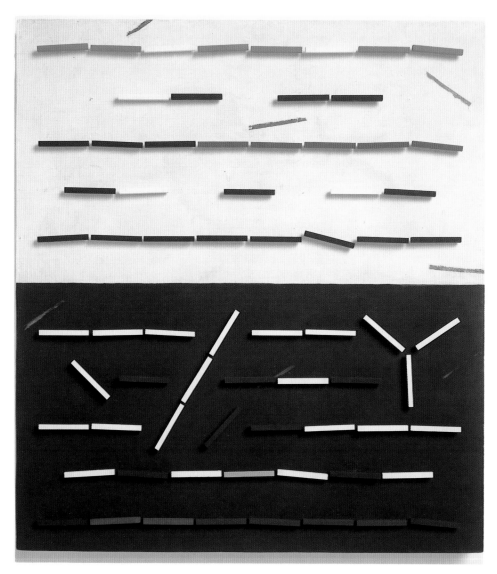

"Day, Night" (1953)

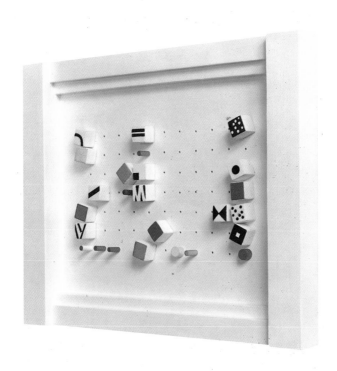

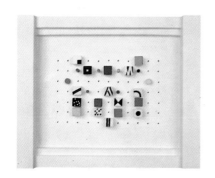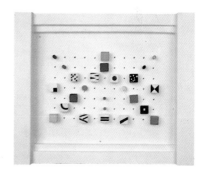

"Sign for a Language", three different views (1953)

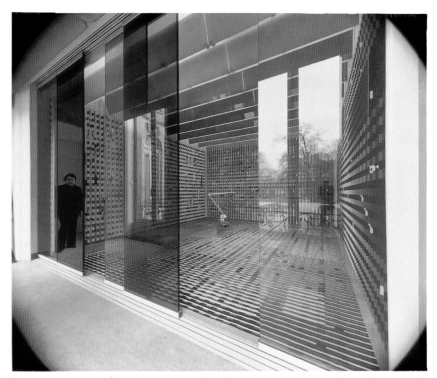

"Salon Agam" at the Elysee Palace (1974)
Commissioned by Georges Pompidou, President of France

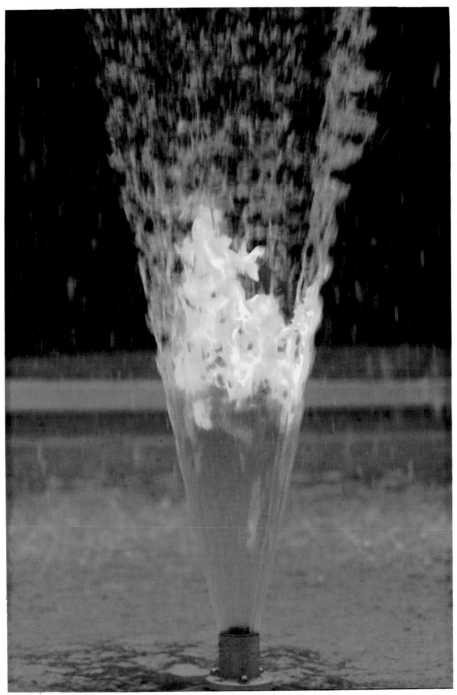

"Fire and Water" (1971)

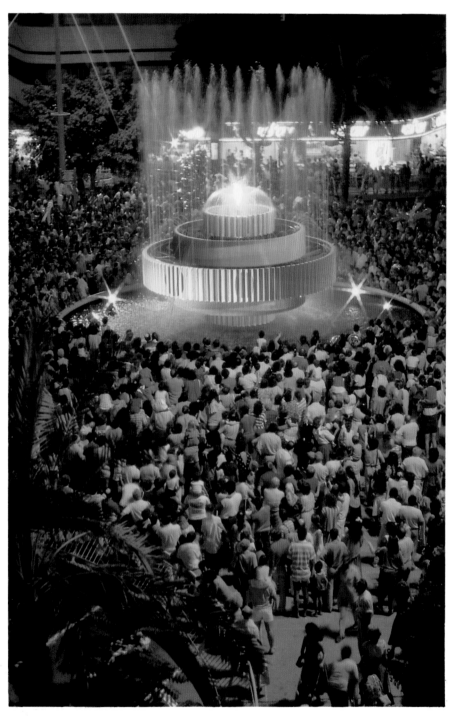

"Fire-Water Fountain" at the Dizengoff Square, Tel Aviv (1986)

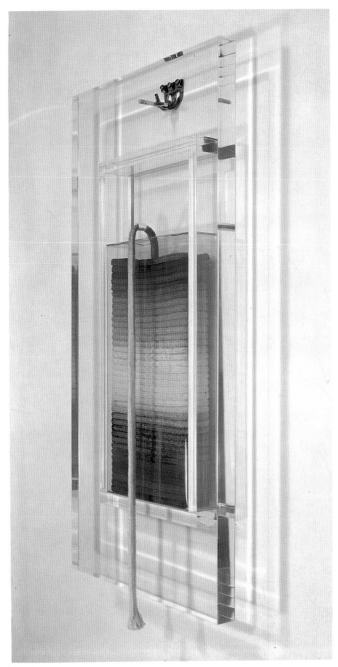

"Thread of Life" (1970)

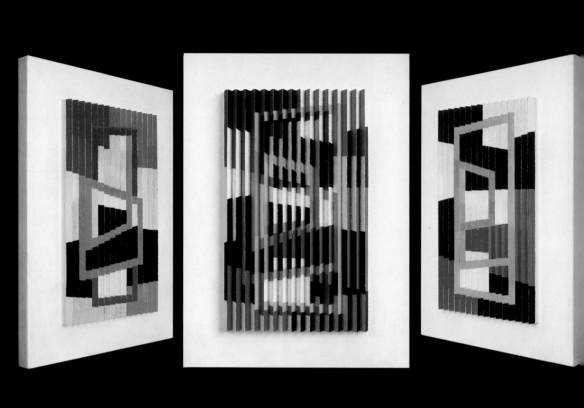

"Orientation", three different views (1957)

"Terem", five different views (1969)

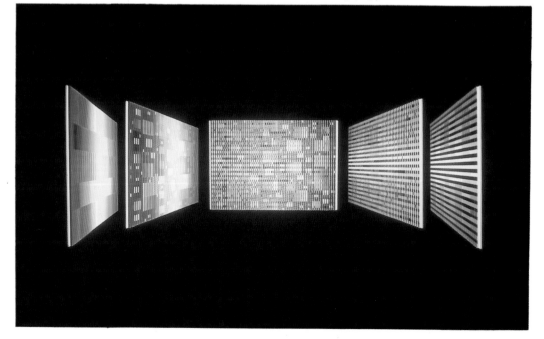

"Villa Regina"
in Miami (1984)

"Constellation 3"
on board the
cruiseship
M.S. Fantasy (1989)

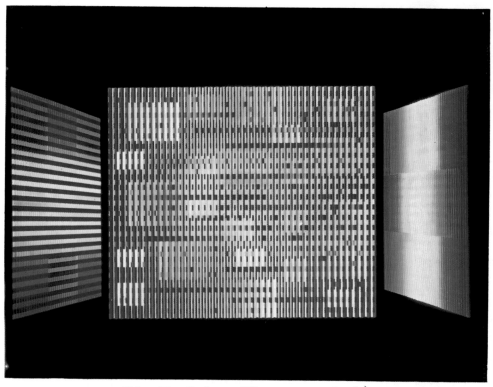

"New Year", three different views (1967)

Opposite Page:
"Ahava", three different views (1993-96)

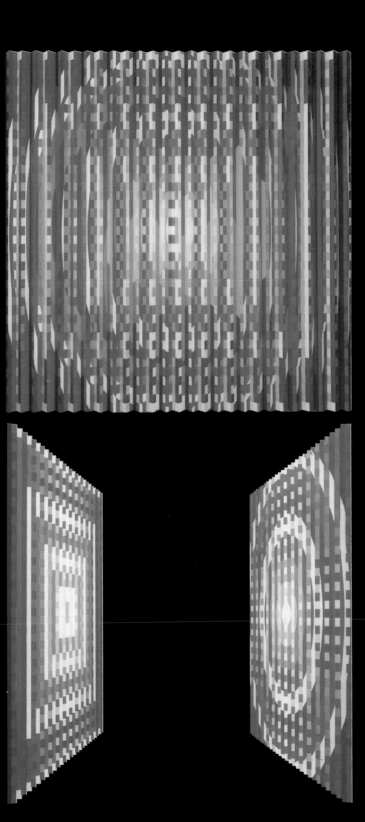

Shimon Peres presenting Agam's "Rainbow Torah" to Pope John Paul II (1994)

Margaret Thatcher visiting the Agam exhibition in Palm Beach (1993)

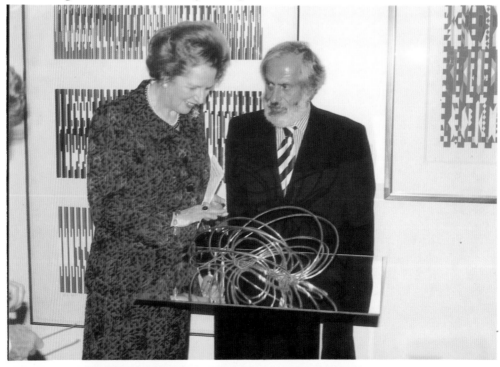

Agam with the children of "Agam Method Visual Education" class in Eilat (1996)

Agam with Hillary Clinton talking about early childhood visual education (1995)

Agam in front of the "Mondrian Hotel", Los Angeles (1984)

to color, light, movement, and, at the same time, technology entwined within art.

Agam and Malina exhibited together in group exhibitions a number of times, including "Art cinétique à Paris: lumière et mouvement" held at the Musée d'Art Moderne de la Ville de Paris in 1967, curated by Frank Popper, a professor of the University of Paris and one of the most important theoreticians of kinetic art. (Popper's book, *Agam*, published by Harry N. Abrams, New York, is one of the most thorough and comprehensive works on the artist.) Agam and Malina enjoyed a good relationship until Malina's death.

As Agam was undoubtedly a forerunner of art in movement, he has often been called the "father of kinetic art." In the mid-1950s, young artists such as Agam, Soto, Bury and Tinguely did indeed give birth and life to art in movement in a very real sense. They were the pioneers, and added life to the contemporary art scene of Paris at the time. Following them, many artists, even established artists who already had their own styles, took on the approach. It became fashionable to include "movement" in art.

"SCANDAL"

In 1968, Agam exhibited one of his major pieces, "Transparent Rhythms II" (now in the collection of the

"Transparent Rhythms II" shown in the exhibition
"Art in France 1900-1967" at the National Gallery (1986)

Hirshhorn Museum and Sculpture Garden, part of the Smithsonian Institution, Washington, D.C.) in an exhibition entitled "Painting in France 1900-1967" held at the National Gallery of Art in Washington, D.C., the Metropolitan Museum in New York and the Art Institute of Chicago. The exhibition was curated by Germain Viatte, now the Director of the Musée National d'Art Moderne at the Centre Georges Pompidou in Paris, and Blaise Gautier.

In general, when setting up a group exhibition, curators do not usually allow individual artists to be involved in the installation, or even visit the exhibition site prior to the

opening. Agam's large work, however, had been dismantled for transportation and the artist was brought in to guide its reassembly when he was lecturing at Harvard University in Cambridge, Massachusetts. It was in this way that Agam saw an exhibit which shocked him greatly. In one of the rooms, he spotted a polymorphic relief painting which was very much in his style. Agam could hardly believe his eyes. Upon inquiry, he learned that the artist who sent this work was Victor Vasarely. "This is not Vasarely's style," protested Agam. "This painting takes after MY style." To the curator who suggested that each artist had the right to show what he wished, Agam responded

Time (April 12, 1968)

vigorously: "Vasarely would never show a polymorph painting which was so obviously 'Agam' in style in France. The French know too well that this is my style, and they would know instantly that this is an imitation of my style. If he did that in France, he would just make himself ridiculous. But here in America, people don't know. If you show it now, here, imagine – people might think that I copied him, just because he is older, and is already known in the United States for his hard-edged, geometrical two-dimensional paintings. That I can't stand." The organizers were finally convinced by Agam's argument, but they were afraid of the scandal which might arise. So they tried to persuade Agam and silence him. However, Agam told them that if they showed this particular work of Vasarely, he would withdraw from the exhibition, and that he would not take part in the assembly of his polymorph painting; rather, he would take it away with him.

In fact, this piece, "Transparent Rhythms II," was one of the biggest pieces in the exhibition. Later, "Time" magazine (April 12, 1968) published a large color photo of Agam's work. While arguing about the abstract canvasses shown that "By comparison with the work turned out by the dynamic U.S. action painters, the French products look timid, prettified and unconvincing," they wrote of French pop artists that "...the rest (other than Arman and Raysse) are merely low-cal imitations of U.S. originals. But when it comes to op, kinetic and geometric art, the clear rational air that bred Descartes,

Pascal and cubism seems to have kept the Paris pop percolating merrily from the past to the present...Across from it (Robert Delaunay) stands Yaacov Agam's 'Transparent Rhythms II,' made of triangular strips of aluminum, so that its patterns jiggle and flicker as the viewer passes."

For the organizers of the exhibition it was impossible for Agam to take away his painting, since it was one of the major pieces to be shown. So they requested that Vasarely withdraw his work. Agam also complained to Denise René, who was representing Vasarely in those days and promoting him very aggressively (until Vasarely left the Galerie Denise René some years later). "Denise, that painting is impossible! And you know that!" Agam protested. After some time, and an exchange of numerous telexes and telephone calls across the Atlantic, Vasarely finally consented to withdraw his painting and sent a different piece for the exhibition.

CALDER

Although far apart in age, Yaacov Agam and Alexander Calder were friends. Agam used to visit Calder at his home and studio in a small village in France. His home was partly carved into a mountain, and one of the house walls consisted of a huge rock. Agam remembers Calder's sense of humor and ability to make jokes. He was a heavy-set man, yet his spirit

Agam with Alexander Calder

was light and lofty, not unlike the mobiles he created. No modern equipment could be found in Calder's studio; the only tools he used were rudimentary ones such as a hammer and iron lever. When Agam suggested that Calder avail himself of modern tools, "Sandy replied that he did not want to be a slave to tools, he liked to be FREE to create," recalls Agam.

The closeness between Agam and Calder was manifested in a number of ways. Agam wrote an article about Calder for the prestigious *XX Siècle* magazine. Calder gave Agam a miniature of his mobile-stabile work as a gift. The two exhibited together a number of times. One prominent exhibition in which the works of both artists were shown was entitled "Bewogen Beweging" (Moving Movement), put

together by the legendary curator William Sandberg and held in 1961 at the Stedelijk Museum in Amsterdam. It later toured to Louisiana Museum in Humlebaek, Denmark, and the Moderna Museet in Stockholm, where unfortunately it was altered by the director, Pontus Hulten, who added unrelated works, such as those by Robert Rauschenberg, which have nothing to do with movement. This was the first international museum exhibition dedicated in its entirety to kinetic art.

Agam at Calder's house (c. 1970)

(Sandberg was a visionary and avant-garde director, who knew how to discover new important tendencies in contemporary art, and he gained fame and acclaim for the exhibitions he organized. He turned the Stedelijk Museum into one of the most influential museums of the time. Later he became art adviser to the Israel Museum, and was involved in shaping the institution. He installed Agam's transformable sculpture "Eighteen Levels" on the walkway approaching the museum building.)

Calder introduced moving parts into his sculpture, to create a magic play of "flying" shapes through a usage of balance. Also, although his two-dimensional art works, mostly gouache, lack movement, the forms themselves evolve a dynamic sense of rhythm. These are some of the reasons, perhaps, why Calder was fascinated by Agam's work and his ability to introduce the changing image and its transformation without having any moving parts. When Agam tried the tentative studies to introduce the fourth dimension (which represents time), so-called "real movement" was only a part of his vocabulary.

Agam continues to remember Calder fondly. "How vivid, active, alive, alert Calder was! As soon as he ate something at the table, he fell asleep while eating – that really surprised me!" recalls Agam with a smile.

CHALLENGES

MARRIAGE

In 1956, Agam married Clila Lusternik from Rehovot, a town only a few miles away from Rishon LeZion, which was founded in part by her grandfather. The two met in Paris when Agam ·was doing cinematographic research for his film "Le Désert Chante." Clila was a second-generation sabra (a person born in Israel, named for the distinctive cactus of the region).

For Jews, marriage and home life is important. "It is like the scale in music," explains Agam, "you try to get over it, but in the end you always come back to it." Although Agam had been leading a Bohemian life before his marriage, he soon settled down and devoted himself to his work. In 1958 his first son was born. (Agam has two sons and one daughter.)

This period was one of challenge and experimentation for Agam. The artist's overwhelming curiosity manifested itself at this time. Agam devised a theory for "simultaneous writing,"

From right: Agam, Simcha Dinitz (Israeli Ambassador to the U.S.)
Clila Agam, and Senator Jacob Javitz at Agam's exhibition

he created a keyboard instrument for interpreting plastic works, made musical transformations, devised a radio with multiple receivers, a multiple-arm record player, and so on. In 1960, Agam set up his present studio at 26 rue Boulard, in the fourteenth arrondissement of Paris.

MULTIPLE-STAGE THEATER IN COUNTERPOINT

During this same period, Agam elaborated the concept and study of "multiple-stage theaters." Instead of showing only a single version of a given situation on stage, it aims (by showing

multiple scenes proceeding simultaneously) to present a reality which is composed of a multiplicity of simultaneous events. This approach broadens the theatrical conception and provides the means of interpreting an event in the complexity of all its aspects. In this type of theater all the events relating to a single action are to be acted out simultaneously on several different stages which surround the spectators. It is of course impossible for the viewers to see all the stages at the same time, but they can turn their heads from one stage to another. They are thus able to see the different phases of the action as they unfold and complete one another. This form of spatial theater makes it possible to follow the action *in its entire complexity*. Viewers enjoy a living experience of theater which is close to reality.

Agam designed these theaters so that the audience can enter the hall from below into the center of the hall itself, instead of coming in from side doors or rear doors as in theaters in general. It creates an effect similar to shifting from one universe to another. Inside, too, in contrast to traditional theaters, where the seats of the audience are lined up in rows, the viewers in Agam's theater are to sit in pivoting and movable chairs, arranged irregularly in the hall with ample space around each of them, so that they can choose the scene(s) they see at any moment. It is designed leaving some chairs unoccupied, so that people can move to another seat if they choose, according to the different scenes playing. In this

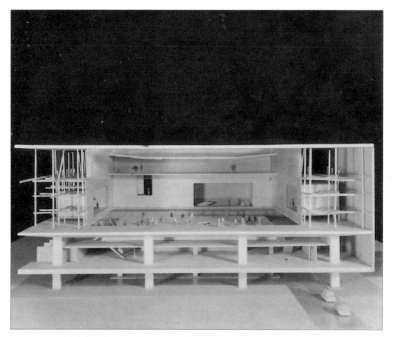

Model for the Multi-Stage Theater in Counterpoint (1962)

theater there are no better seats, or poorer ones, because action(s) could take place from any side.

An architectural model and plans of the multi-stage theater were displayed at a group exhibition titled "Antagonismes II: l'objet" held at the Musée National des Arts Décoratifs du Louvre in March, 1962, and Agam's *Manifesto* was also published on that occasion. This display of the model aroused considerable interest and attention. Jean-Louis Barrault, one of the greatest French actors and stage directors of the modern theater, was one of the first to become interested in Agam's

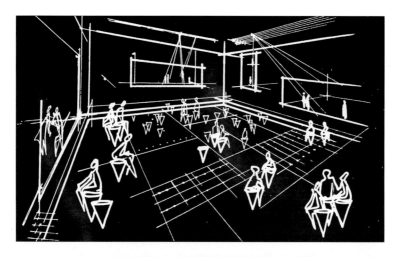

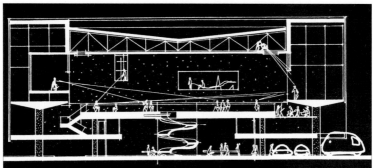

A drawing for the Multi-Stage Theater in Counterpoint

theatrical concept, which he saw in the exhibition at the Musée des Arts Décoratifs. "When I received a telephone call, and the other side identified himself as Jean-Louis Barrault, I replied 'Here is Napoleon!' because Jean-Louis Barrault was so famous and considered as an authority or a master of the theater, I thought someone was pulling my leg or making me

the butt of a joke!" reflected Agam. But it was Barrault, and he invited Agam to his office. Barrault was very excited about Agam's idea and told Agam that, although such a theater had not existed yet, he would like to direct in it when it was constructed.

It was also Barrault who aroused the famous playwright Eugène Ionesco's interest and led him to see this model of the multiple-stage theater. Actually Ionesco was quite overwhelmed by this concept. "How could two or more scenes be performed simultaneously without the audience losing their minds?" asked Ionesco. "This will not happen," replied Agam, "the audience will grasp the whole. Viewers will be aware of what is going on. Their powers of perception will be

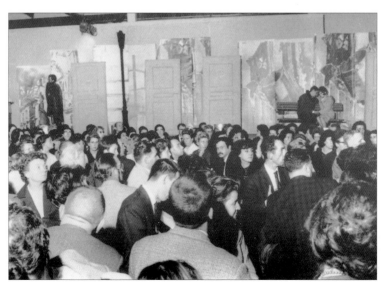

Multi-Stage Theater in Counterpoint (1965)

multiplied. The most sensitive part of the body is the neck from where all the nerve systems flow to the body." The conversation ended with Ionesco still feeling skeptical. He nevertheless promised Agam he would write a play especially for this theater if and when a multi-stage theater was built for that purpose.

In 1965 at the theater festival ("Le festival des nuits de Bourgogne") in Dijon, Agam finally realized his idea in a real theater, with a special grant from André Malraux, the French Minister of Culture and a famous author. He staged a theater with multiple scenes "in counterpoint," with the audience in the center, sitting on pivoting chairs, surrounded by the four scenes which were played simultaneously. "The spectators were able to hear and understand everything," wrote Ionesco with astonishment, and he later became "obsessed with Agam's idea" (quotation from his essay "The Theater of Agam" written for the book *Hommage A Yaacov Agam* (Numéro Spécial de XXe Siècle) published at the time of Agam's retrospective exhibition at the Guggenheim Museum in 1980).

The story about the performance of the multiple-stage theater in Dijon is as follows: Claude Parent, architect and a member of the editorial board of the magazine *Architecture d'aujourd'hui*, helped Agam with the architectural drawings from which the model was made. He introduced Agam to his brother Michel Parent, who was inspector of National Monuments in France, as well as a writer. He was very much

impressed by Agam's idea of the multiple-stage theater, and decided to write a play especially for such a multiple-stage theater. Michel Parent also talked to Jean-Marie Serreau, a stage director.

The play which Michel Parent wrote for the project was about the pilot of the Enola Gay who dropped the atomic bomb on Hiroshima on August 6, 1945. At the beginning of the play the pilot was a hero, since the disaster caused by the atomic bomb was thought to accelerate the decision of the Japanese government to surrender, thus bringing World War II to an end. Then, tormented by the idea that he caused hundreds of thousands of civilian deaths, the pilot became a priest. After that, his mental state deteriorated seriously, and this is depicted graphically on several stages. Later, he had to enter a mental hospital, and finally he committed suicide. He was represented simultaneously at different stages in different situations of his life, such as in childhood, as a pilot, etc., and in his inner drama at different phases of psychology, which went into the depths of his heart. All of this was shown simultaneously on four stages surrounding the audience. At a certain point of the play, some eighteen different scenes were shown at the same time on four stages.

Pol Kaniel, a scholar and then Israeli Cultural Attaché in France, who witnessed this project in 1965, made the following comments: While many post-modern inventions in the field of theater were based on a certain *vagueness* or

Top: Agam with Rene Magrit

Bottom: A group of artists at an opening
of the Exhibition Manifeste 1993, Centre Georges Pompidou
Right to left: Agam, Bury, Dewasne, Zao Wou-Ki, Soto, Alesinsky

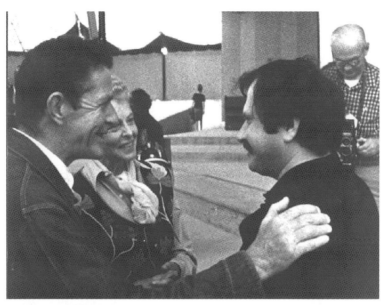

Top: John Cage and Elizabeth Pepke congratulating Agam
after he delivered a lecture at the International
Design Conference in Aspen, Colorado (1996)
Bottom: Zubin Meta at Agam's Atelier in Paris fascinated
by Agam's multiple-armed record player which can play
limitless variations of music (1962)

Mrs. Walter Annenberg (middle), Frank Sinatra and his wife in front of Agam's sculpture "Touch Me" at the opening ceremony of the Agam Exhibition held on an occasion of the inauguration of Palm Spring Desert Museum (1980), Palm Springs, California.

Top: Agam presenting a model of his biggest menorah in
the world to be installed at Fifth Avenue, New York, to
Rabbi Schneerson, at the Chabad headquarters in New York.
Bottom: Kirk Douglas with Agam in Los Angeles.

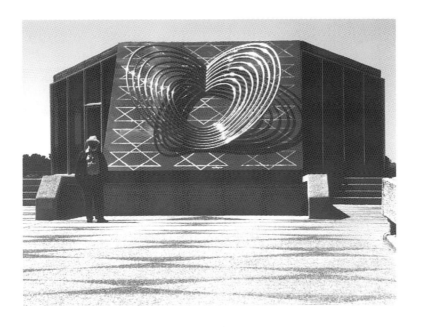

Top: An environmental scale sculpture "Beating Heart" installed on the hill overlooking the Israeli Parliament and the Israel Museum, Jerusalem

Bottom: President Michael Gorbachev with Agam. After becoming President of Russia, he acquired Agam's original silk screen graphic work of the rainbow image.

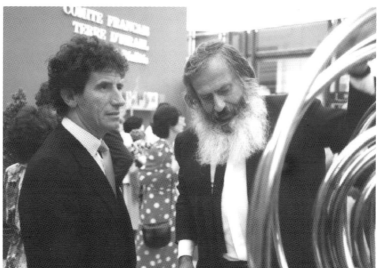

*Top: A visit of French President François Mitterand
to Agam's atelier in Paris (1992)*

*Bottom: Jack Lang French minister of Culture in front of Agam's
sculpture at the exhibition "Israel through the Ages"
held at the Petit Palais Museum, Paris (1968)*

Top: Agam with his mother on a Friday night in Israel (1983)

Bottom: Agam receiving Honorary Doctorate from
the Hebrew Union College, New York (2001)

Agam using his invention, the Agamoscope, an artistic tool employing mirrors to allow each eye to see differently and combined, created for his retrospective exhibition "Agam — Beyond the Visible" at the Guggenheim Museum in New York (1980)

irrationality which tried to *hide the reality* (in their efforts to break the barrier of the classic), Agam's idea does *not* hide anything, but rather shows very clearly that *you cannot see everything*. Agam's "polyphonic stage" shows *the immaterial*. "It turned out to be a great success," reflected Kaniel. "This project received a lot of reaction in the theater festival, and lots of press reviews, too. *Le Monde* and *Le Figaro* (French newspapers) sent their special theater correspondents to Dijon to cover it. After the project was well received, Michel Parent as well as Jean-Marie Serreau tried to claim that the success was due to them (even though Serreau was reluctant at the beginning to have the audience surrounded by four stages, or to present multiple events simultaneously: actually Agam had to persuade him very hard to accept this idea!). Some of the critics, however, attributed the concepts (of the multiple-stage) to the playwright and the stage designer, without recognizing that the original concept was Agam's. That discouraged Agam somewhat."

Agam's idea started with one principle: that a man does not and cannot see everything around him – actually, most things are beyond the visible, although he might have *a notion* of what is happening; and that a man does not listen from only one source of sound, either. It is the *human mind* which makes the selection. For Agam, therefore, the theater should have not only one source of image and sound but rather multiple sources. That is polyphony, polyvision, and counterpoint. This

is exactly the same concept which is behind his kinetic paintings. These simultaneous actions enable him to treat the same subject using different forms and in different nuance: one in tragedy, one in comedy, one in tragi-comedy, and so on.

In his "Conception Scénique et Conception Théâtrale," a sort of manifesto written in Vichy on September 6, 1965, which appeared in *Les Entretiens sur le Théâtre* (November-December 1965), Agam says, "For me the theater is a mode of *prise de conscience* of the reality. The theatrical conception is the language by means of which this *prise de conscience* is being realized." He also adds, "Nobody in my theater can see

VARIATIONS ON THE SAME THEME:
Journeys Among the Dead

by
Eugene Ionesco

Performed in
Yaacov Agam's
MULTI-STAGE THEATER
Beyond The Visible

Directed by
Paul Berman

WORLD PREMIERE PRESENTATION

October 1980

Catalog for the Multi-Stage Theater "Variations on the Same Theme: Journeys Among the Dead"

the same thing" (as on an ordinary theater stage). This is exactly the same concept as his painting, and one could say further more that in this multiple-stage theater in counterpoint, the concept is shown more purely and clearly (since the viewers become dazzled, when viewing the paintings, by the beautiful colors and interesting shapes themselves, and do not always realize the plastic concept behind them). Therefore, to see the theater as planned by Agam gives us a better guide for understanding his painting and sculptures.

In 1980 (nearly two decades after he saw the model in the Musée National des Arts Décoratifs du Louvre), on the occasion of Agam's retro- spective exhibition held at the Solomon R. Guggenheim Museum in New York, Ionesco wrote a multi-stage play especially to be performed in Agam's multi-stage theater. As promised, the piece was written solely for Agam's theater, and it in fact turned out to be one of the very few pieces that he wrote not very long before his death. The piece was entitled *Variations on the Same Theme: Journeys Among the Dead*. The scenes were set in the world after death, where, for instance, a son spoke with his parent who was much younger (because his parent was much younger than he was when he died); or a man met the girlfriends he had at different periods in his lifetime; or a woman's nails became a monster's nails – a sort of macabre comedy. Audiences were given mobile chairs specially designed by Agam on which they sat in order

to be able to choose the direction they faced. (Unfortunately at this performance, due to the compromise initiated by the American producer, performances were held on only three, instead of on four stages which would have *surrounded* the audience. Agam was not happy about this change from the original idea because it completely distorted his concept of the multiple-stage theater as a possibility for future theater, as well as a challenge to human perception.)

Coincidentally, both Agam and Ionesco were presented with Honorary Doctorates from Tel Aviv University in 1975.

In these various trials and experimentations made by Agam, we see the different phases of multi-dimensional art. These various trials have in common the fact that they include a multi-dimensional, multi-levelled process working simultaneously, thus challenging the limits of *human perception*. It is important to point out that this has been Agam's concern from the very earliest stages of his career. Years later we can see that the seeds, sprouting from these challenges, will bloom and be realized with the use of modern high-tech.

SAÕ PAOLO BIENNALE

Agam was awarded the prize for "Artistic Research" at the Saõ Paolo Biennale of 1963. The prize had been created

especially for him when the judges, impressed by Agam's talent but unable to decide whether his work constituted painting or sculpture, established a new category.

The late Dr. Haim Gamzu, an art and theater critic, and then Director of the Tel Aviv Museum of Art, wrote that the prize from the Saõ Paolo Biennale functioned as a springboard for the young Agam. From then on, he became a well-known figure internationally. In 1968 Agam was invited to be a guest

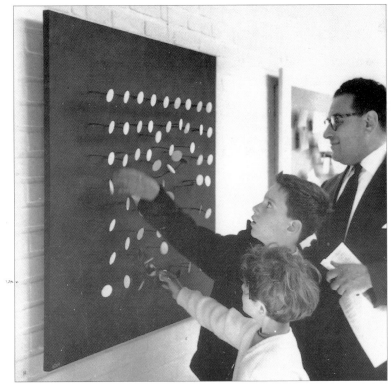

Tactile painting shown at the Saõ Paolo Biennale (1963)

lecturer at Harvard University where he conducted a seminar entitled "Advanced Exploration in Visual Communication" at the Carpenter Center for the Visual Arts. Agam's first stainless-steel sculpture was made in this year. In 1970 Agam's environmental painting for the Forum Leverkusen in Germany was installed. The next year one of his most popular graphic techniques, the "Agamograph" (a multidimensional graphic) was developed. Also created that year were a monumental sculpture for the Parc Floral in the Bois de Vincennes in Paris and a transparent mural and Torah ark for the Park Synagogue in Cleveland. Agam received the "Palette d'Or" award at the International Festival of Cagnes-sur-Mer.

Agam with his student at the Computer Graphics Department
Harvard University (1968)

WALTER ANNENBERG

At about the same time, Agam began to have an impact on the American public art scene. America's enterprising spirit, accompanied by its wealth, enabled Agam to broaden his artistic activities. Within a short space of time, works by Agam could be found in museums, buildings and public spaces in many American cities. Many of his works were bought by local collectors. For example, Walter Annenberg, a former ambassador to the United Kingdom and a wealthy businessman, who was the owner of *TV Guide*, is an important collector of art (his collection of Impressionist paintings was recently donated to the Metropolitan Museum of Art and the

Walter Annenberg with Agam

collection was shown in a special exhibition). Annenberg and Agam met at the artist's exhibition, a part of the inauguration events of the Palm Springs Desert Museum in California (the inauguration was also a part of the ceremonies for America's Bicentennial). Annenberg and his wife Lee came to the opening and bought a piece by Agam. In spite of the museum's request to leave it there until the end of the show, Annenberg wanted to have it right away and took it home. This was a sculpture, entitled "Square Waves," installed at the entrance to the exhibition. From then on Agam was commissioned to create a number of art works for Annenberg's home and offices in Philadelphia. For the inside and outside of his house in Rancho

"Square Waves" (1976), Annenberg Estate

Mirage (near Palm Springs), he made several sculptures and murals. He spent several months to find a special paint that would not fade in the harsh desert sun. He finally chose the binder (to be mixed with the pigment) used for airplanes and boats. At one stage Lee Annenberg requested Agam to have one of the colors of the mural outside the house match the color of the wall. A few years later she complained to the artist, "Color of your painting has changed." In fact, however, it was not the color of his painting which had changed but, rather, the paint on the wall which had faded under the sun!

"Sunny Land" (1977), Annenberg Estate

MUSEUM SHOWS AND PUBLIC WORKS

Agam was commissioned to produce larger and more prominent works. He created a huge mural for the ceiling of a convention center in Jerusalem in 1964. The work was titled "Jacob's Ladder" and depicted the Biblical story of Jacob's dream (in which he saw the angels of God ascending and descending on it, and God revealed Himself to Jacob). In 1975 Agam designed a monumental fountain for La Defense, a complex in Paris, which was made up of an immense mosaic on the floor of the pool, polymorphic side walls, and a computer-controlled fountain capable of displaying water

Retrospective, Musée National d'Art Moderne (1972)

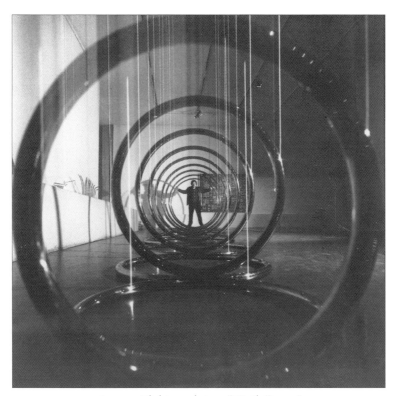

Agam with his sculpture "Ninth Power"
Retrospective, Musée National d'Art Moderne(1972)

movement in manifold ways. Whole facades of buildings were designed by Agam, such as the Villa Regina in Miami, the Mondrian Hotel in Los Angeles, and the Dan Hotel in Tel Aviv. With their multi-colored, polymorphic exteriors, these buildings function as huge kinetic sculptures in their environments. Retrospective exhibitions of Agam's works were held around the world. One of the first took place in 1972

at the Musée National d'Art Moderne in Paris, which then went on tour to the Stedelijk Museum in Amsterdam, the Städtische Kunsthalle in Düsseldorf, and the Tel Aviv Museum. "Agam: Beyond the Visible" was held at the Solomon R. Guggenheim Museum in New York in 1980, and in 1989 the author curated a retrospective exhibition entitled "Agam: Father of the Kinetic Art" at the Isetan Museum in Tokyo, the Daimaru Museum in Osaka, and the Kawasaki City Museum in Kanagawa. In 1996, the author curated an exhibition "Yaacov Agam" at the Museo Nacional de Bellas Artes in

Agam with a model of the exhibition at the Guggenheim Museum

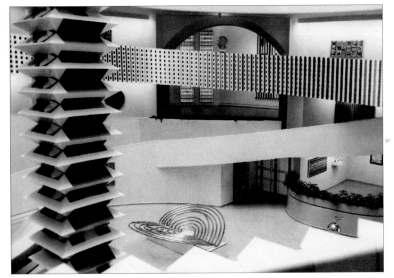

Agam's retrospective exhibition at the Guggenheim Museum (1980)

Buenos Aires, Argentina. (This exhibition is scheduled to travel to the Museo Nacional de Artes Visuales in Montevideo, Uruguay, in the same year and the Museo Nacional de Bellas Artes in Santiago de Chile in 1997.)

Agam was made Chevalier de l'Ordre des Arts et Lettres in 1974, and in 1985 he was appointed Commandeur de l'Ordre des Arts et Lettres by Jack Lang, Minister of Culture. Agam was decorated by the French Minister of Foreign Affairs, Roland Dumas, in a ceremony held at the French embassy in Israel.

Agam Exhibition at the Museo Nacional de Bellas Artes, Buenos Aires (1996)

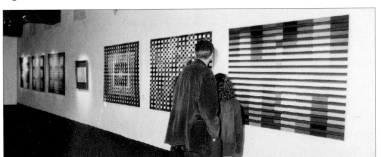

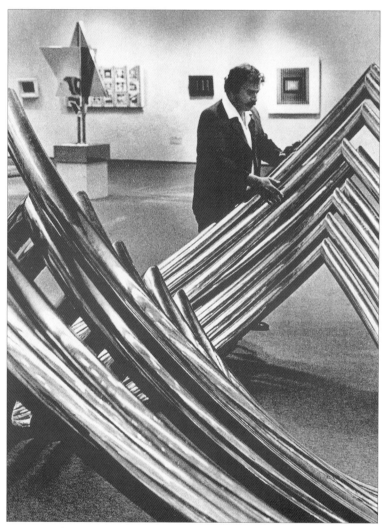

Agam and "Beating Heart" at his retroscaptive at the Tel-Aviv Museum (1972)

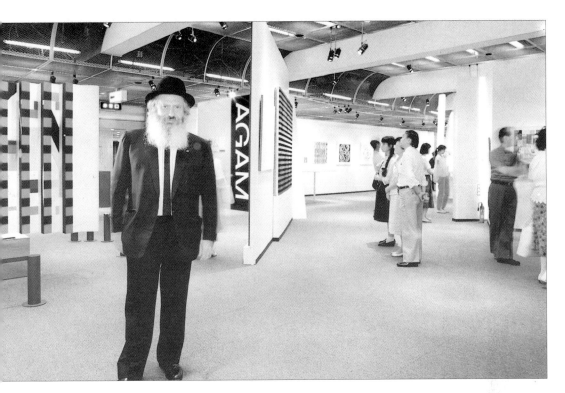

Retrospective exhibition, "Agam: Father of the Kinetic Art" (1989) in Tokyo (above) and Osaka (below)

DIVERSITY OF FORMS

METHODS AND MEDIA

In order to communicate his ideas about life, reality beyond visible change and transformation, time, and the sacred, Agam uses a variety of media. At this point, it is appropriate to take a brief look at the many modes and techniques of his art and some of the best examples:

TACTILE WORKS

Usually the composition of a painting stays in a same configuration forever. However, in the Tactile Works of Agam there is no given composition. The forms which are to appear in the tactile works are completely unexpected. The viewer touches the surface of the work, creating wavy movement (like a stone thrown into a pool of water) of the elements, attached by means of springs, and thus creates new images which disappear in a matter of seconds. The piece responds to the sensitivity of the viewer.

TRANSFORMABLE PAINTINGS

Transformable paintings can be touched, turned and changed; viewers may move mobile elements to new positions. Any movement, however small, alters the appearance of the whole work, as the work does not have a traditional pre-determined structure. These works, with their dynamism enhanced by the elements of movement and time, overcome the limitations of fixed composition and open the entrance to the fourth dimension. As already mentioned, it was this aspect of Agam's work which attracted Surrealists such as Ernst, Breton, and Arp.

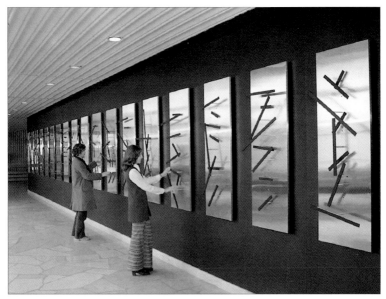

Transformable painting "Living Wall" (eighteen times "8+1 in Movement")
University of Montpellier (1968-69)

POLYMORPH

Polymorph, a relief made up of countless triangular pillars, is also notable for the fusion of its changing colors and shapes. It looks different according to the direction from which the audience views it. Several different images are hidden in a single painting – they appear, fuse together, disappear and reappear, depending on the viewer's eyes, just like polyphonic music and counterpoint. The image someone sees from the front is different from the left or the right, while the image seen from the right cannot be seen from the left or the front. Thus the audience enjoys viewing the polymorph as "visual music"; each person is the conductor because to each viewer the

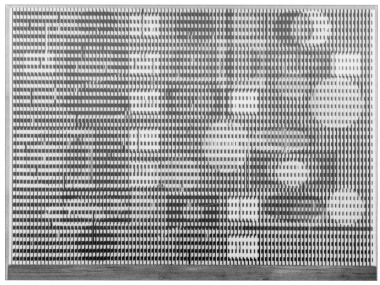

Polymorphic painting "Double Metamorphosis II" (1964-65),
Museum of Modern Art, New York

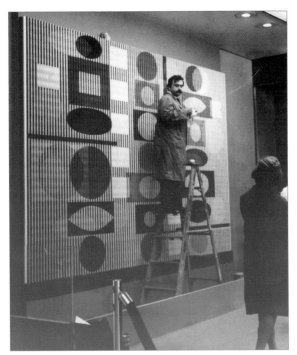

Agam working on "Double Metamorphosis II" at the entrance of the M.O.M.A.

painting yields an original look. For example, if somebody stands beside you and looks at the same Agam painting, the result is that the two viewers are seeing completely different images within the same painting. For no one can ever see the whole picture, since it is always metamorphosing. The image one sees at one moment never stays the same, since the audience shifts stance as time passes. The image is not static, but rather fragile and kinetic. In addition, between one image

and another, there still exists a number of possibilities which are yet to be discovered. Therefore, it can be said that the *invisible aspect* of the polymorphic painting is constantly present, *even more so than the visible aspect*, and that it can never be seen at once as a whole. Like the contents of a book or a piece of music, the passing of time is necessary for the whole work to be successively revealed. "Transparent Rhythms II," found in the Hirshhorn Museum and Sculpture Garden of the Smithsonian Institution, provides a good example of Agam's polymorphic art. From the far left, the viewer sees only

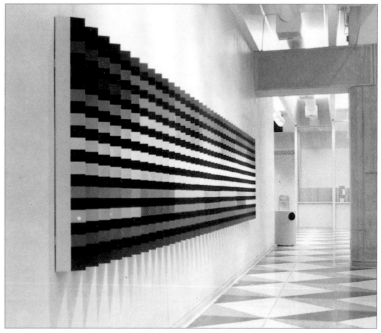

Polymorphic mural painting "Visual Reading" (1985)
Public Library, Fort Lauderdale, Florida

black and white stripes which open into a structure that differs by its essence from lines, then to a structure which crystallizes in forms and colors; as one moves step by step toward the right, various images appear and disappear. It is as if each viewer were playing an original and different tune on a visual instrument.

KINETIC SCULPTURES

Transformation and movement are integral elements of Agam's sculptures, known as transformable or kinetic sculptures. Viewers arrange and change the position of the

Agam with "Eighteen Levels" (1971)
at the Israel Museum

*Ezer Weizman with "Touch Me" sculpture at
Agam's exhibition at the Guggenheim
Museum (1980)*

elements (as in the works "Eighteen Levels," "Ninth Power"
shown at his retrospective at the Musée National d'Art
Moderne in Paris, and "3 x 3 Interplay" installed at the Julliard
School of Music in New York). In other sculptures, a gentle
touch causes motion and metamorphosis of the whole work
(as in "Beating Heart," one of Agam's most popular and
interesting sculptures). In these works, there is a shape, but,
at the same time, there is not a static, defined form. It is based
on the Jewish concept of the form (which could be found in

Kinetic sculpture "Hundred Gates" (1972)
Residence of the President of Israel, Jerusalem

the Kabbalah), *"there is no form except in the complete form, and the complete form is infinite."* That is why Agam strove to make a form that will include the infinite change and transformation within itself, and the infinite possibilities, without altering the sense of *the notion of a form*. Its capacity for change means it may take on multiple, sometimes infinite, appearances.

An example of Agam's kinetic sculpture which combines aesthetics with spiritual values is "Hundred Gates," installed in the garden of the President of Israel's residence in Jerusalem. In Hebrew, "Hundred Gates" translates as "Meah Shearim," which is the well-known name of an ultra-orthodox quarter of

Jerusalem. In the spiritual labyrinth of Jerusalem, at each step a different realm unfolds. Since the gate functions as a passageway to a different world, this special gate "Meah Shearim" depicts the gateway to a higher spiritual level. The strong middle-eastern Sun playing on Agam's sculpture creates a sharp contrast of light and shadows, cast on the clean, pure, white base of the garden.

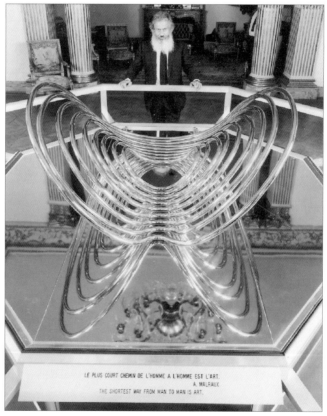

Kinetic sculpture "Wings of the Heart" (1986)

*Agam with André Malraux at the exhibition
"Israël à travers les âges" at the Petit Palais, Paris (1968)*

"Wings of the Heart," which is found in the international arrival building of the John F. Kennedy Airport in New York, provides another example of kinetic sculpture. It combines aesthetics with advanced technology. The work was a gift of Air France to the American people, presented on the fortieth anniversary of transatlantic flights, and on the centennial of the presentation of the Statue of Liberty by the French to the American people. "For a century, the Statue of Liberty has welcomed foreign travellers, and immigrants as well, to the United States," explained Agam. "Now people don't travel by

sea; they arrive by air. So, as a new symbol which represents the same values as the original statue, such as freedom, welcome, hope, and peace," it was installed in the airport in 1986. "Wings of the Heart" features nine heart-shaped stainless steel elements, placed on (but not connected to) a mirror surface, which continuously move, sometimes slowly and sometimes rapidly – like the wings of birds. The movement and rhythm are controlled by a computer through electro-magnetic impulses. A smaller version of the same work was shown in Japan in 1989, and is now installed in the main lobby of the Asahi Brewery building in Tokyo. On "Wings of the Heart" Agam engraved a phrase of André Malraux: "The shortest way from man to man is art."

Through these sculptures, sophisticated in their refined simplicity but nevertheless reflecting an infinite diversity of form, Agam presents a *situation* which evokes nonexistence and invisible possibilities of a given space. In fact, the sculpture as a fixed entity *does not exist*. All that exists is an infinite number of possibilities contingent upon audience participation.

TELE-ART

Usage of electro-magnetic waves and light has widened the scope of art. Agam's tele-art is a good example of work in this field. "Let There be Light," first shown in 1967 at the Musée d'Art Moderne de la Ville de Paris in the exhibition "Art

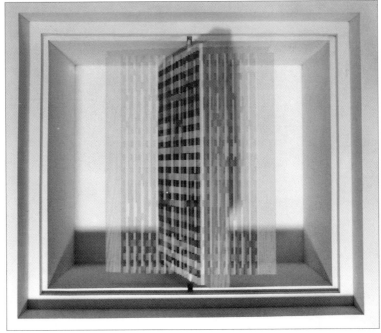

Tele-art, "Painting Rhythmed by Light" (1967)

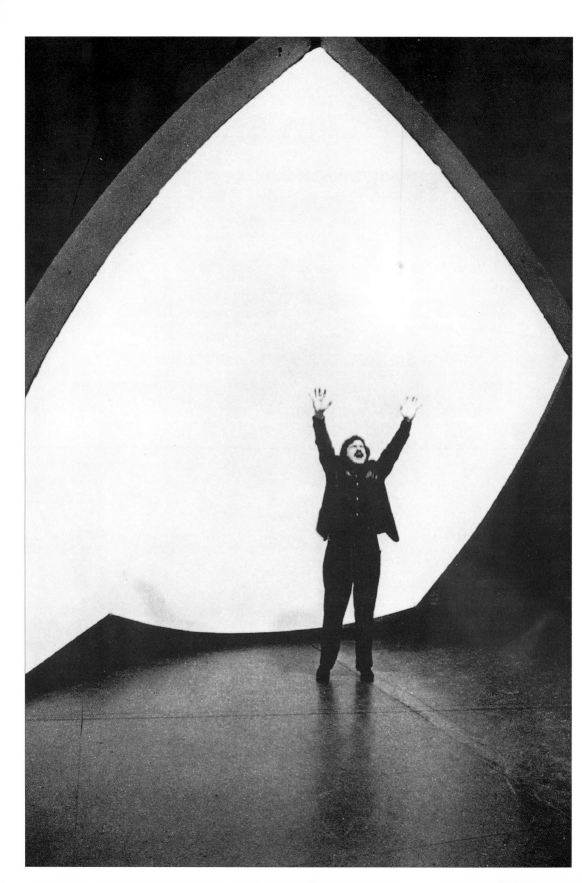

cinétique à Paris: lumière et mouvement," clearly and symbolically demonstrates his approach. The piece consisted of an egg-shaped inner space with a single light bulb in the center. The light responded to sounds made by viewers: acoustic waves were transformed into electro- magnetic waves, creating visible light rhythms. Here, art transcended the limitation set by matter (materials) and space. A second example, "Painting Rhythmed by Light" (1967), is a double-sided polymor- phic painting with nine different themes, put in a wooden box, rotating at a high speed of 1440 revolutions per minute. When turning, images disappear completely, become transparent, and appear only with intermittent flashes of a strobe light. If the flashes are released successively at the same rate as the rotations, the illusion that the painting is standing still, suspended in mid-air, is created. If the flashes are released at double the rate of the rotations, both sides of the painting can be seen at the same time, although this is impossible for the naked eye. What is seen, therefore, is an illusion, while the real image remains invisible. Here, viewers are exposed to the *absence of the image* which Agam presents so tactfully. The purpose of tele-art, explains Agam, "is to transcend the object and create an artistic 'situation' independent of it." That is, to transcend the material existence by facing the "absence of the image." According to Agam, tele-art "splits a painting into many images, moving in each different direction. Tele-art makes tangible an invisible reality: it radiates, projects, and evokes an

◄ *Tele-art, "Let There Be Light" (1967)*

image which to the viewer reveals the invisible and irreversible forces of material reality. Here the artistic expression depends upon the immaterial radiations conceived or controlled by the artist, reflected through the artist's usage of modern technology" (F. Popper, "Agam," Abrams, New York). In Agam's tele-art, combined with modern technology are the ancient Hebraic philosophical concepts of *reality beyond the visible* and of the *invisible but omnipresent God*.

COMPUTER ART

Computer Art consists of digital images created directly on the computer by Agam. One of these works, "Visual Music

Agam working on his computer art "Visual Music Orchestration"

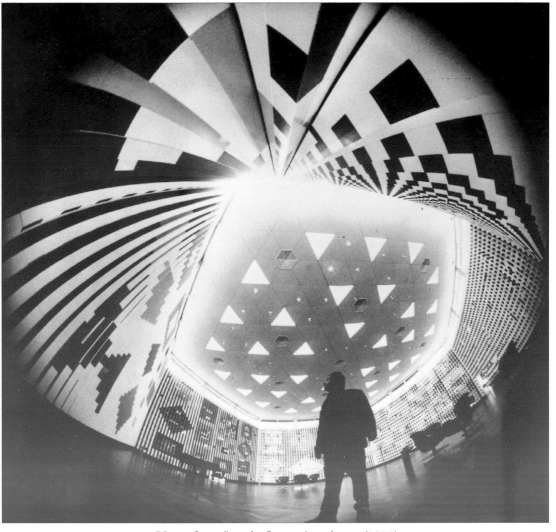

"Agam Space" at the Forum, Leverkusen (1970)

Orchestration," which was made on sixteen separate screens, received the Grand Prize at the Artech Biennale (for art and technology) in Nagoya, Japan in 1989. Another work in this genre is in the collection of the Tel Aviv Museum.

ENVIRONMENTAL WORKS

In the 1970s, in the inevitable process of evolution, Agam expanded the scale of his kinetic paintings and sculptures to

the environmental and monumental scale. In these environmental sculptures, viewers can stand within, rather than merely observe, an artistic reality. The "Agam Space" (1970) at the Forum, a cultural center in Leverkusen, Germany, provides an example of this. There, the immense interior walls of a hexagonal hall are covered with six monumental polymorphic murals. The effect for those inside the halls is that with each of their steps the imagery of the total space is transformed, and they are made to feel as if they are walking *inside a painting.*

"SALON AGAM" AND PRESIDENT POMPIDOU

The "Salon Agam" (completed in 1974), created for the Elysée Palace (the mansion of the President of France) at the request of the late President Georges Pompidou, provides an excellent example of kinetic painting on a monumental scale. President Pompidou wished to change the militaristic atmosphere of the Elysée Palace which had been created by his predecessor, Charles de Gaulle. The Inspector General of Creative Arts in the Ministry of Culture, Anthonioz, contacted a number of leading sculptors, such as Giacometti, Calder, Agam, etc. and invited them to submit works. Anthonioz told Agam that Pompidou had recently visited the exhibition "New Acquisitions" at the C.N.A.C. (National Center of Contemporary Art), and had seen the newly acquired work by Agam, "Transparent Rhythms." According to Anthonioz,

Pompidou had spent a great deal of time looking at Agam's work, going back and forth in front of it. It was the work that had captivated him the most. When he received Anthonioz's call, Agam had a sculpture on exhibition at a chateau in Saint-Germain-en-Laye. Pompidou saw the work and chose to place it in his office. The modern piece, however, looked out of place on a conservatively-decorated base. Agam was asked to come to the Elysée Palace to view the room and the sculpture in order to design a stand for the work. Almost immediately he felt that this would not be enough; rather the atmosphere of the room had to be changed. "You cannot just change a table. You have to change the whole environment of the room," Agam told the President. A few months later, Agam received a call from the President and Mme. Pompidou in which they offered him an entire room to design and shape as he saw fit. No conditions were placed on Agam as Pompidou recognized the importance of freedom of artistic expression. He told Agam that he himself was not an artist, and that it was not for him to instruct the artist on how to paint! Pompidou did not even want to look at the model of the room, so as not to influence the artist. When Agam was installing his work, the President would visit the "salon" to see the progress. Pompidou reiterated over and over, "Because of the salon Agam, I would be forever present in the Elysée Palace, since no future president would ever dare to remove the room which is so representative."

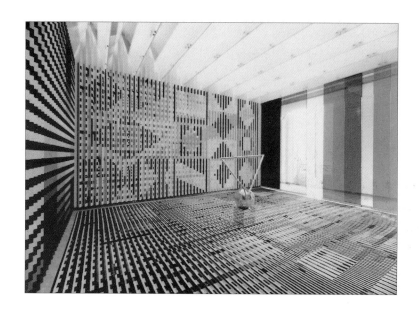

Above: "Salon Agam" of the Elysée Palace (1974)
Below: Agam checking a tapestry at the Gobelin atelier

Agam with Eugène Ionesco inside "Salon Agam" at the Pompidou Center

The "Salon Agam" was a masterpiece. It was an entirely kinetic environment. Three walls consisted of a polymorphic painting, and the ceiling featured polymorphic translucent panels, creating the effect of a sky with sunny colors or passing clouds. On the floor was a carpet with 180 colors, woven at the Gobelin atelier, and the entrance (fourth wall) consisted of transparent, colored sliding panels, which changed the complexion of the inner space, thus completing the total effect of a new artistic environment. In the middle of the room was a sculpture called "Le Triangle Volant," a stainless steel, mirrored sphere placed on a base. Seemingly suspended above the sphere was a triangular shape. In the mirror surface of the

sphere, the visitors can see themselves in the center of the entire space.

Pompidou died before the salon was completed. Valéry Giscard d'Estaing became the next President in 1974, and, at the request of Prime Minister Jacques Chirac, the salon was completed. Later, when Giscard and Chirac had a falling out, following a political dispute over the election of the Mayor of Paris, Giscard ordered that the "Chirac Salon" be removed from the Elysée Palace. (When Giscard's protégé was running for Mayor of Paris, Chirac suddenly and quite unexpectedly declared his candidacy. This, in fact, infuriated Giscard. He was

10th Anniversary of the death of the late President Pompidou, held at the Marie de Paris (1983) From right: Mme. Pompidou, President Mitterand, Agam, Édouard Balladur, Paris Mayor Jacques Chirac

worried that his protégé might lose the election, and that was what really happened.) Agam's salon was moved to the Centre Georges Pompidou, where it formed part of the modern art collection. In 1983, "Agam's Salon" formed part of a tenth-anniversary ceremony in honor of the late President Pompidou held at the Mairie de Paris (city hall of Paris). Bordas, Director of the Musée des Arts Décoratifs du Louvre at that time, then argued that the rightful place of "Agam's Salon" was in the Louvre; thus the work was not returned to the Centre Pompidou. The salon is now in the collection of the Musée des Arts Décoratifs of the Palais du Louvre.

MONUMENTAL WORKS

Further examples of environmental-scale works of kinetic painting include the façades of buildings mentioned earlier, such as the Dan Hotel in Tel Aviv, the Mondrian Hotel on Sunset Boulevard in Los Angeles, and a Miami condominium

Dan Hotel, Tel Aviv (1986), two different views

Above: "Memorial Flames" atop the Haidrah Rabbah study center near the Western Wall (1987)
Below: Agam with Rabbi Goren Photo: *Arthur Frank*

Torah Ark, synagogue in Palm Springs, CA. (1987-88)

called Villa Regina. These are buildings turned into huge outdoor kinetic sculptures. Their outside walls are huge polymorphic paintings, whose image looks different according to the angle at which you face them. Pedestrians or drivers passing in front of the building, or viewers from the air in a helicopter or an airplane can enjoy the transforming images of the building's rainbow colors. It thus vivifies the entire environment.

Another example of the adaptation of a sculptural form to its environmental scheme is the kinetic sculpture "3 x 3 Interplay" (1970-71) created for the Julliard School of Music at the Lincoln Center in New York City. According to Agam, it

was made as a "sculptural instrument for space performance." The audience was encouraged to participate in arranging the "instrument for visual music" by modifying the elements of the artwork.

"Memorial Flames" provides yet another example of art in this genre. This piece is a memorial to the six million Jews who perished in the Holocaust, and was installed on the roof of the Haidra Rabbah Yeshivah catercornered to the Wesrern Wall of the Temple (Wailing Wall) in Jerusalem. The letters of the Hebrew word *Yiskor* יזכור ("remembrance") are placed between panes of transparent glass which look like candles. On top of each candle is a mirror-like, metallic Star of David, blazing in the light. Stained-glass windows, a Torah Ark, and a Torah Mantle in a synagogue of the Hebrew Union College in New York, a Torah Ark in a synagogue in Palm Springs, California, and the stained-glass windows of a Holocaust center in Jerusalem provide further examples of Agam's contribution to Jewish spiritual and historical sites.

GRAPHIC ART

While artists have long been involved in graphic art, Agam has sought to bring new qualitative elements such as movement, time, change and transformation to this medium; that is, to introduce the fourth dimension to what has been until now only two-dimensional. Each piece of graphic art is capable of transformation, would thus be unique and lead to

Agam supervising the printing of "Tapigraphy"
with silkscreen printer W. Arcay

an expansion of the visual possibilities. Agam has attempted to achieve this through a number of techniques and modes.

I. **AGAMOGRAPHS**, in which images change constantly, just as in polymorph paintings. This is made possible through the combination of a precise lithographic printing process and a surface-mounted lenticular lens. Several images are combined, enabling the viewer to see one of the images from a particular angle, or to see a combination of images. Despite being a graphic, the fourth dimension is at work here: the artwork is activated and transformed by the participation of

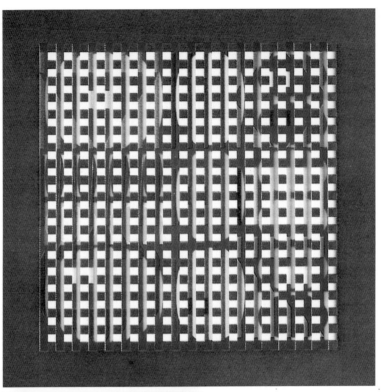

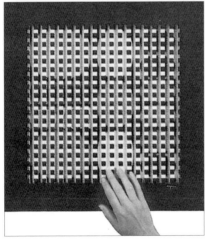

viewers. The entire work cannot be seen at any one moment; time is needed to view the whole. Agam achieved this kinetic, non-static reality which appeared in front of viewers by presenting only a *partial* revelation of the whole visual information in one work. "My endeavor has been to create a kind of visual graphic artwork, existing not only in space, but in time, in which it develops and evolves, thus producing a foreseeable infinity of plastic situations flowing out of one another," explains Agam.

2. **MULTIGRAPHS** are a form of serigraphs, with a movable grid placed over the image. This grid can slide to the right or left, thus exposing the viewer to different compositions according to the position of the grid. The hidden is more present than the visible, and is constantly explored in the interaction of two superposed images.

3. **DYNAMOGRAPHS** consist of several transparent images. Viewers can slide each of the images, combining and fusing them, in a process of visual evolution.

4. **SPACEOGRAPHS** are three-dimensional pieces, comprised of numerous modular units in high and low relief. The units are serigraphed onto plastic. Each represents its own unity of space and composition, but taken together, they form a large whole. This is based on a theory that every entity of the universe is based on separate, independent pieces.

◄ *Multigraph "Rencontre"*

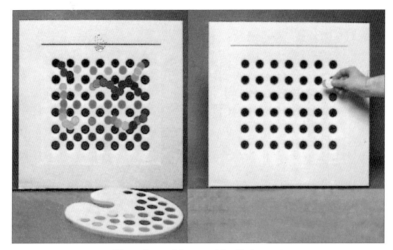

Transformable graphic dialogue

5. In INTERSPACEOGRAPHS, the space between two (or three) transparent images is (are) used to define the relationship between them. Through the exploration of depth and space as defining the interrelationship between the two (or three) static images, change is created by viewers' participation.

6. PRISMOGRAPHS are two-dimensional prints partially covered by a series of transparent prisms. The combination of a two-dimensional graphic and three-dimensional prisms creates a multi-dimensional vision, somehow similar to polymorphic painting, as the prisms serve to pick up, and hide as well, the distinctive compositions of the graphic.

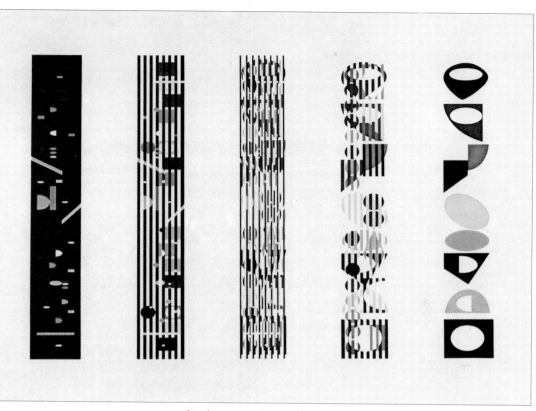

Single print suites "Full Day"

7. SINGLE PRINT SUITES are groups of related single compositions within one image. Each transforms into the next, going from simplicity to complexity and returning to simplicity, in a cyclic pattern. The sequence creates a sense of orchestration of images within one print.

8. SEVERAL PRINT SUITES consist of a series of independent prints, each related to the other and linked by a unifying theme. The viewer's eyes follow the images in progression, as if reading a score. This offers the viewer a means to understanding the mechanism of the polymorphic painting by clearly showing the process of change and transformation. One image metamorphoses into the next, creating a harmonious cycle of visual music.

9. VIDEO ART has also been explored. Most of Agam's pieces in this genre were created in 1974, and were shown in a one-man exhibition at the Galerie Attali on Boulevard Saint-Germain in Paris. The exhibit consisted entirely of different video art images on television screens. The video art pieces were created in a television studio: several cameras zoomed in and out of Agam's transformable works under his direction. At some points, image synthesizers were used. This was a very advanced methodology at that time.

10. DIFFRACTION GRADING GRAPHIC is printed by a laser beam on a fully transparent surface; then, only when the light source is seen through this usually transparent glass, multiple images appear. One of Agam's most famous works of this type is a Star of David, viewed in a circular glass (like a monocle). Another example is a coin made for the Israel Coin and Medal Company which has at its center a tiny transparent surface through which one can look. Agam was striving to create an image beyond the visible: images appear only in response to particular circumstances, that is, by exposure to strong light sources.

11. HOLOGRAPHS are single prints registered on a photosensitive surface. With a strong light behind it, the image appears to have depth of space, and this optical illusion takes place as the viewer steps in front of the holograph. Images also appear to move independently within this

holographic space. One of the best known of these works is entitled "Homage to Einstein."

12. **ELECTRONIC ART** consists of interactive computer displays in which the viewer may modify the rhythm at which images change, the size of the images (through the use of a zoom), and the color scales.

13. In **TRANSFORMABLE GRAPHICS** the viewer arranges and rearranges the composition.

14. **MULTIDIMENSIONAL GRAPHICS** are printed on different levels of transparent material, creating a sense of depth and movement – thus allowing for the entry of the third and fourth dimensions into graphics.

15. **SYMPHONIC GRAPHICS** consist of a series of graphics on the same theme and of the same form spread, but using different color variations.

16. **REVOLVING** and **SPINNING POLYMORPHS** are free-standing, double-sided polymorphs. A two-dimensional graphic is attached to a corrugated three-dimensional surface. The viewer may then touch and turn the work, producing an ever-changing orchestration of different images. In this case, it is the polymorph which turns, rather than the viewer who moves.

* * *

In most of Agam's works, simple, basic, and neutral forms are used rather than complex images. When people first see these works, they naively misunderstand (because of the simplicity of the forms) that they are under the direct influence of Dada and Bauhaus. In fact, simple, clear, and almost *innocent* forms are most conducive to presenting movement and change, and are thus able to show the complex transformation of the image. That formulation might sound paradoxical. However, there is a rather self-evident reason, for a complex image could easily distract the inexperienced viewer, who will then close his or her eyes to the possibilities yet to occur (which image might develop and evolve during the process of change). But viewers, exposed to simple and clear forms, could easily become aware of the process of change, and furthermore, become vaguely aware of the existence of *something invisible* behind those changes. In short, the basic nature of Agam's imagery means that the viewer becomes more interested in possibilities of change and transformation, and life beyond the visible, rather than being content with what is evident in front of his or her eyes.

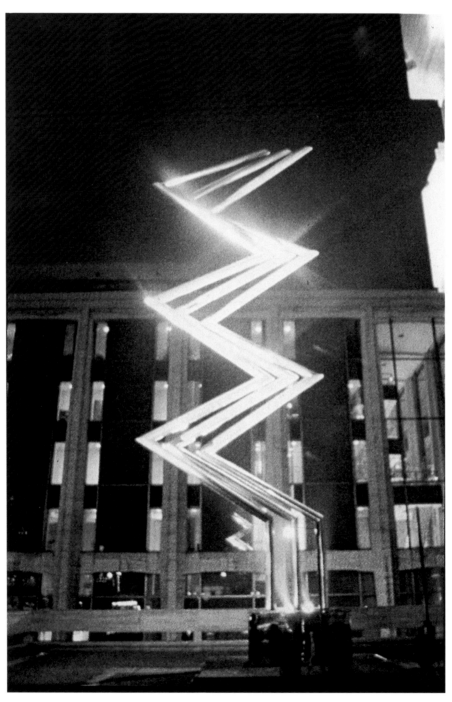

"Three Times Three Interplay" (1971)
at the Julliard School of Music, Lincoln Center, New York

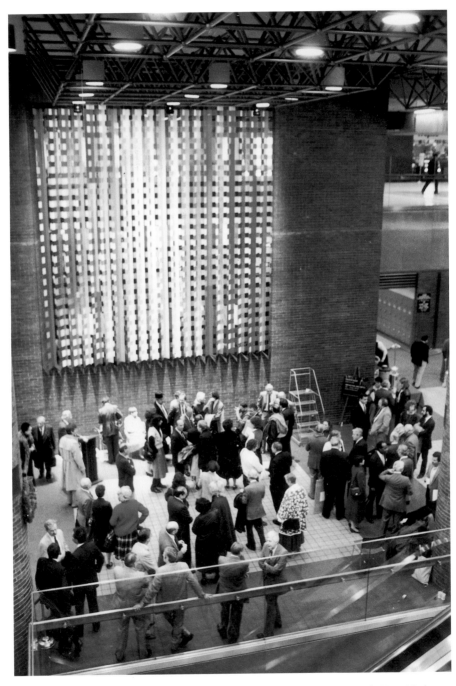

*"Reflection and Depth" (1984) at the Port Authority Bus Terminal, New York,
that won an art competition organized in collaboration
with the major museums in New York*

"Sunny Land" (1977), Annenberg Estate Photo: Roberta Feuerstein

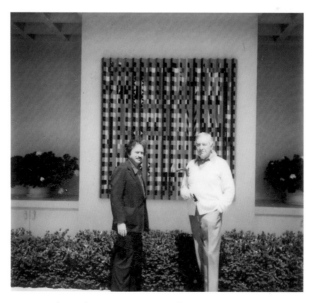

Agam with Walter Annenberg in front of his outdoor mural painting "Sunny Land", Annenberg Estate in Rancho Mirage

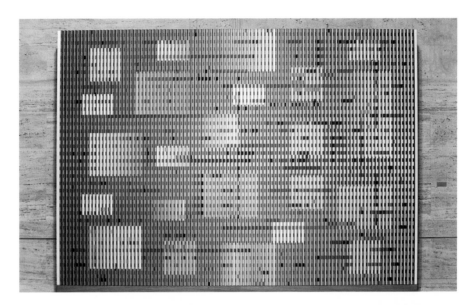

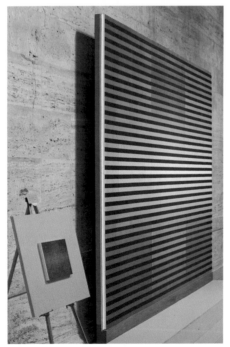
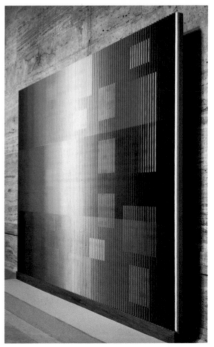

*"Transparent Rhythms II", three different views, shown in the exhibition
"Art in France 1900–1967" at the Metropolitan Museum, New York and at
the Smithsonian Institution, Washington, D.C.
Collection Hirshhorn Museum and Sculpture Garden Smithsonian Institution,
Washington, D.C. below left. Miniature Model of "Transparent Rhythms II"*

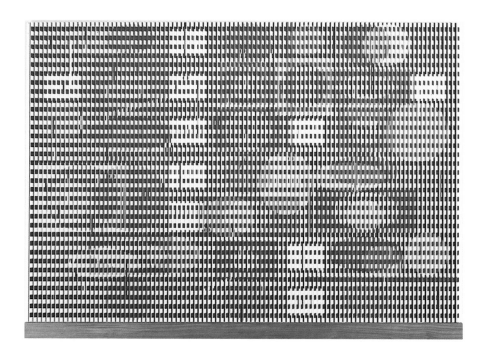

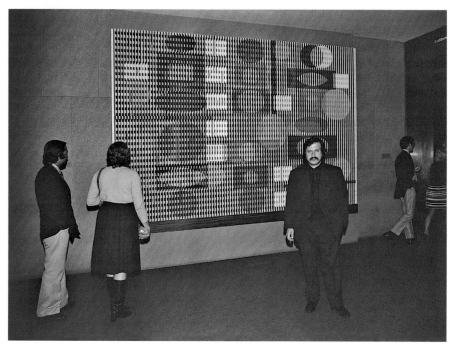

"Double Metamorphosis II", two different views,
Museum of Modern Art, New York (1964)

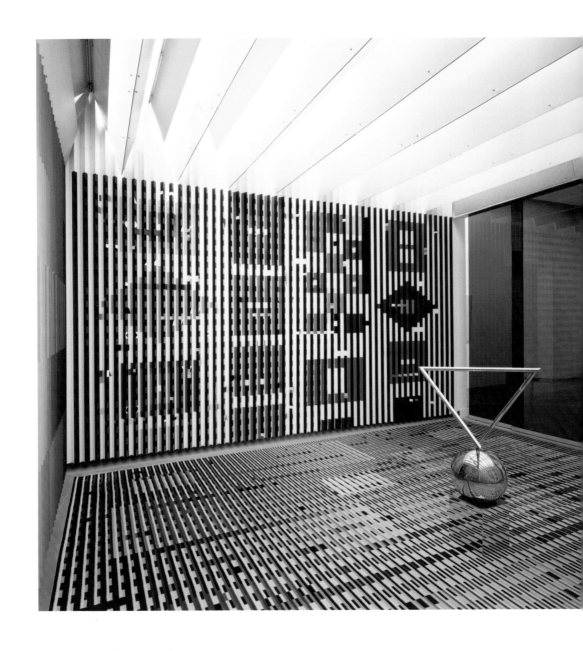

Kinetic sculpture "Triangle Volant" placed at the center of "Salon Agam"
commissioned by President Georges Pompidou
for the Elysée Palace, Paris (1974)

Total environment is reflected on the sphere

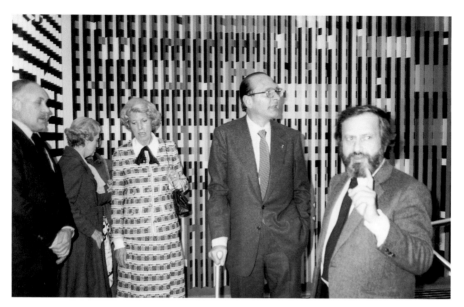

Mrs. Claude Pompidou and then Paris Mayor Jacques Chirac inside "Salon Agam"
at the installation of the Salon at the Musée National d'Art Moderne,
Centre Georges Pompidou (1976)

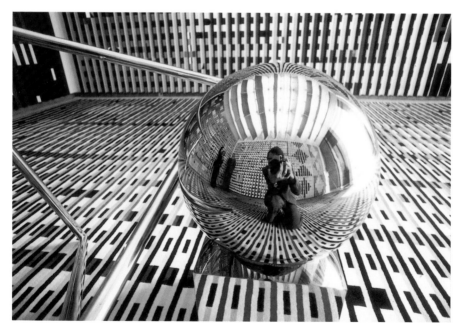

"Triangle Volant" in "Salon Agam" at the Elysée Palace (1973). In this picture, the
photographer is seen at the center, while at the corner Agam is explaining to then
newly-elected President Valéry Giscard d'Estaing about the Salon (1974)

"Salon Agam" in the permanent exhibition of the Musée National d'Art Moderne. Centre Georges Pompidou. Paris. On the left side is the painting "Transparent Rhythms III." The public is not allowed to go into the Salon. so they can understand the space concept through the multi-dimensional painting.

Part of "Salon Agam" shown in the exhibition "Georges Pompidou et la modernité" at the Galerie National du Jeu de Paume, Paris (1999)

Monumental fountain at La Défense complex, Paris (1975) with 66 vertical water-jets and 5 multi-petal tulip water-jets

In the center of the photo on the opposite page, the Arc de Triomphe can be seen, as "Agam Fountain" is located at the end of the Triumphal Axis of the city of Paris which begins at the Palais du Louvres, and includes Place de la Concorde, Obélisque, Arc de Triomphe and the Grande Arche of La Défense.

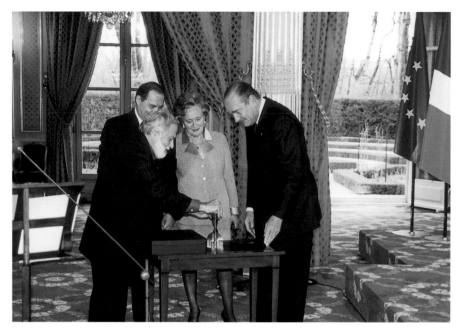

Agam demonstrating the kinetic sculpture menorah to President and Mrs. Jacques Chirac at the Elysée Palace, offered by the Anti-Defamation League. Behind Agam is A.D.L. President A. Foxman

Agam with Mrs. Bernadette Chirac in his atelier, in front of "War and Peace" (2000)

Exhibition "Yaacov Agam" at Château de Sédières, Corrèze (2000)

Agam explaining about his work to Mrs. Bernadette Chirac and the Governor of
Corrèze, at the opening of the exhibition "Yaacov Agam"
at Château de Sédières, Corrèze (2000)

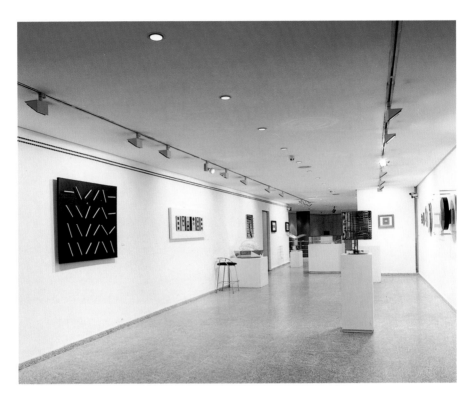

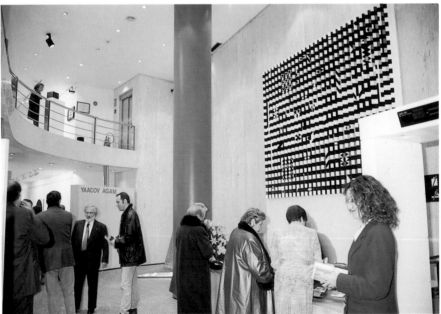

Exhibition "Yaacov Agam" at the Fundacion Arte y Tecnologia, Madrid (1998)

A computer art (left) and "Totem" (1970) at the exhibition "Yaacov Agam" at the Fundacion Arte y Tecnologia, Madrid (1998)

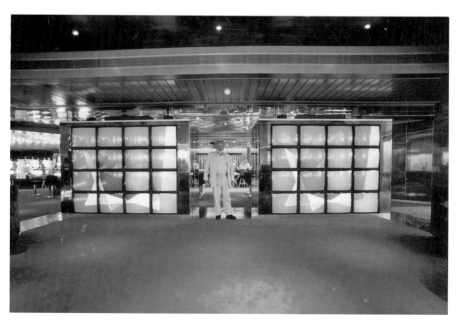

"Visual Music Orchestration" on the cruiseship M.S. Maasdam (1997)
Double 16-screen computer art evolves thousands of different images

Agam's Hanukah Menorah at the corner of 59th Street and Fifth Avenue in New York City is the largest menorah in the world

Agam (left) lighting his Hanukah Menorah on top of the lift

"Memorial Flame" (YIZKOR-Remember) atop the Haidrah Rabbah study center near the Wailing Wall, Jerusalem (1987)

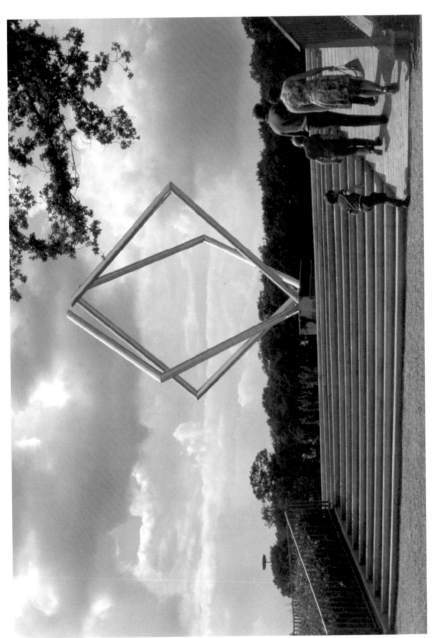

"Super Line Volume" in the Floral Parc, Bois de Vincennes. Paris

"Touch Me" sculpture — a Caress for Peace.

The position of the elements of the large monumental sculpture responds to the position of the reduced-size model which can be touched and rearranged by the viewers, thus enabling them to engage in a direct, creative dialogue between the artwork and the public on the highest level of creative participation. The idea of Agam is to place such a sculpture in different capitals of the world. For example, touching a sculpture in Paris would move the other in New York, Tokyo, or elsewhere by satellite communication, thus realizing the artistic communication which goes beyond the limit of time and space.

*Agam in front of the model of the residential building Torre Bosques in Mexico City,
in company with the architect B. Romano. The colorful mosaic facade
was created by Agam. Below are details of the facade.*

Agam with the model of the Neeman Towers complex on the seashore of north
Tel Aviv and in front of a completed building (Architect Kenaan Shenhav)
Colorful composition of Agam turned the building
into large-scale environmental artwork

Stained glass windows and Aharon Hakodesh (tabernacle) created by
Agam for the central main synagogue in Zurich. Agam is standing in
the light coming through one of the stained glass windows.
Different from the Christian churches with their dark interiors where
the stained glass windows are strikingly bright, Jewish people, in a
synagogue, are supposed to pray in a space filled with light. Agam's
stained glass windows are a visual prayer which illuminates and
sanctifies the space with light and color.

Agam in his atelier in Paris with the sketches for the stained glass windows for the synagogue in Zurich on his working table and a real-size sketch hung behind him. Agam checking the colors of the stained glass with Mr. Dieter Scholz of Zurich who produced the stained glass before the panels were assembled and installed. Up at right, prayer at the synagogue.

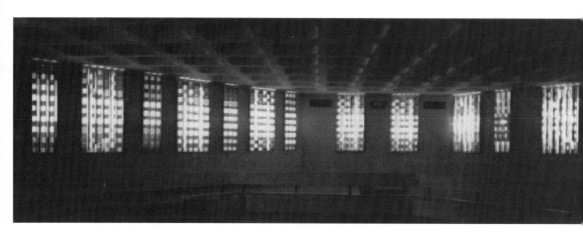

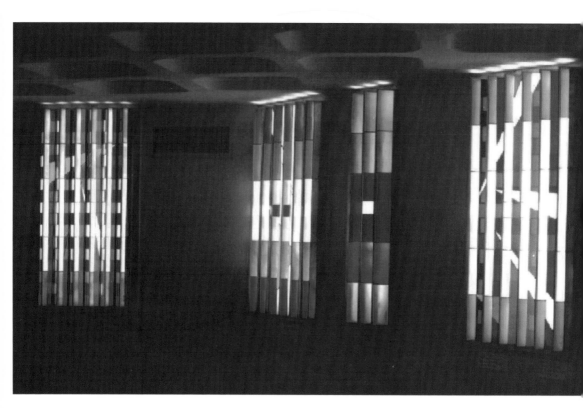

Multidimensional stained glass windows that change the images from every angle

Jossy Berger Holocaust Study Center of the Emunah Women of America Community College, Jerusalem (1987)

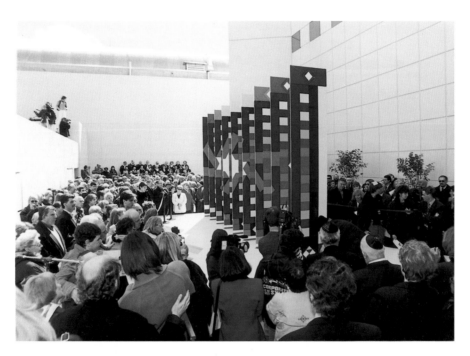

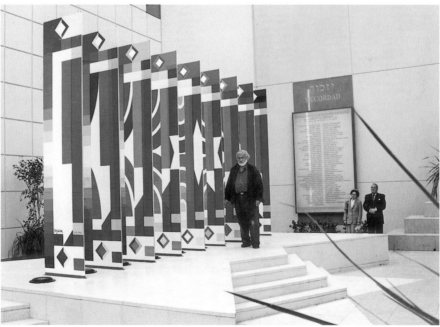

"Remembrance and Hope," two different views (1998)
A monument created in memory of the victims of the bombing of the AMIA building
in Buenos Aires, commemorating the Jewish Community Center's reconstruction

"Evolution I and II," five different views each (1994)

Two polymorph paintings that look different from the front evolve to look the same from extreme right and extreme left

"Magic Dream I and II," five different views each (1997)

Two polymorph paintings look the same from the front, while they surprisingly look different from left side and right side

"War and Peace," five different views (1999)

"War and Destruction," five different views (2000)

"Peace and Enlightenment," five different views (2001)

Opposite page: "War and Peace": Starting from an angular expression of conflict (extreme right side) which evolves into a more aggressive form (the 2nd image) and then into another image of complexity and disorder seen from the front (the 3rd image), it then evolves out of the chaotic images, transforming itself into a friendly, circular form of détente (the 4th image), and finally terminates in the surprisingly serene appearance of a colorful spiral of rainbow colors expressing peace, progress and harmonious evolution (the 5th image).
"War and Destruction" Out of the first theme of angular and violent expression evolves a more threatening image, which arrives at a climax in the frontal view. Then it develops into a destructive image of a battlefield, to end in fire, blood and ashes.
This page: "Peace and Enlightenment": The spiral image develops into a more powerful expression of light and color, which evolves into enchanting harmony, to further develop into a circular expression of colorful movement. It then terminates in an open space expressing liberty.
The different images that exist in the painting appear, disappear and fuse together according to the angle at which they are viewed.
The paintings "Evolution I and II", "Magic Dream I and II", "War and Peace", "War and Destruction" and "Peace and Enlightenment" are of the collection of Eli and Anita Jacob — Miami, Florida.

Drawing of the environmental setting of the project for the Holocaust Memorial to be installed on the waterfront in New Orleans, Louisiana. In the center of the Holocaust Memorial is a monumental work painted on double-sided aluminum panels with 18 different views symbolizing the story of the Holocaust and the revival of Jewish life. Here are six of those images: 1. Yellow star symbolizing the humiliation; 2. Color-form in memory of the millions of victims; 3. An image of destruction of all the human values; 4. Image of the sky as symbol of hope and divinity; 5. Appearance of the Jewish menorah made out of the rainbow and its reflection; 6. A visual blessing for progress and life.

Mme Simone Veil in Agam's studio near the model of the Holocaust Memorial for New Orleans

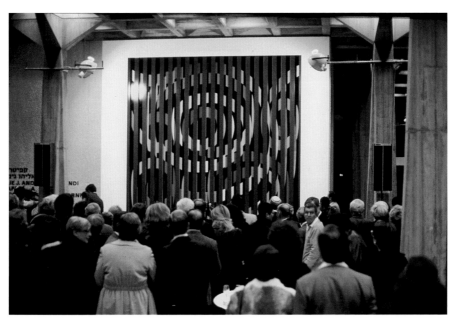

"Becoming" at the main entrance hall of the Tel Hashomer hospital, Tel Aviv suburb (1985)

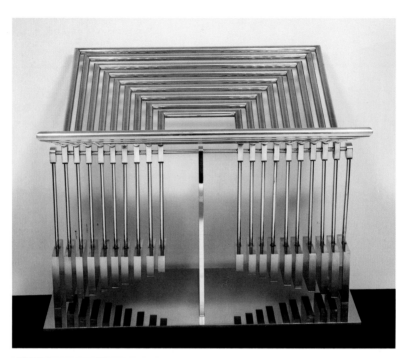

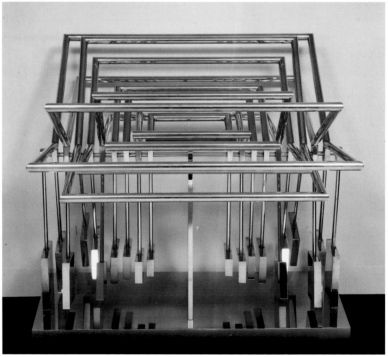

"Square Waves," two different views (1989)

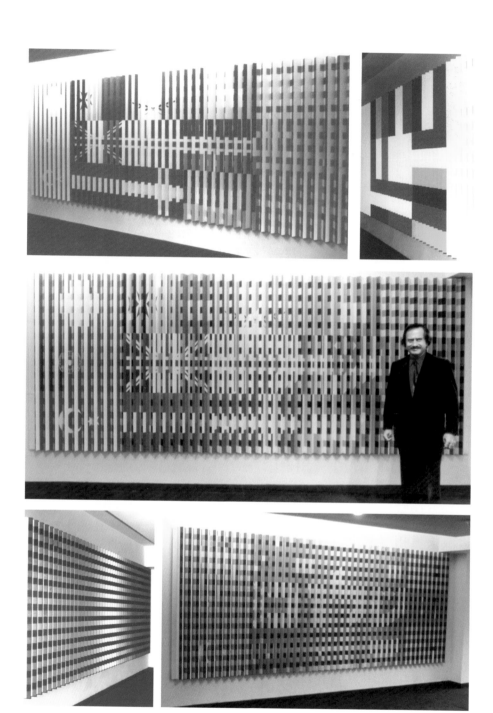

"Peace," five different views, European Parliament, Strasbourg (1977), given as a gift by the Israeli parliament, shows the flags of the member countries of the European Union fusing into a rainbow and the Hebrew word for peace, "shalom"

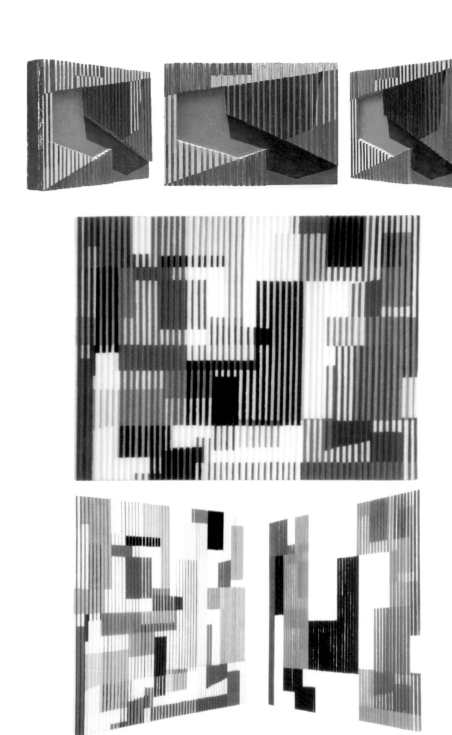

Top: Untitled, three different views (1950), one of the very first polymorph paintings
Middle and bottom: "Composition," three different views (1953)

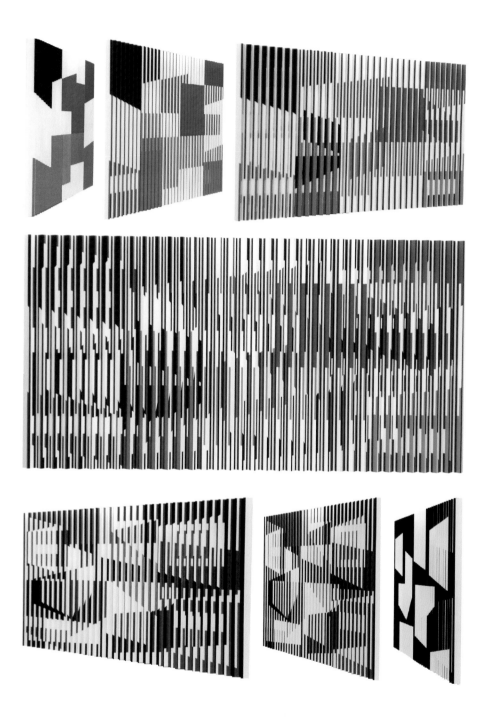

"Homage to J.S. Bach," seven different views (1963), from minimalism to maximalism

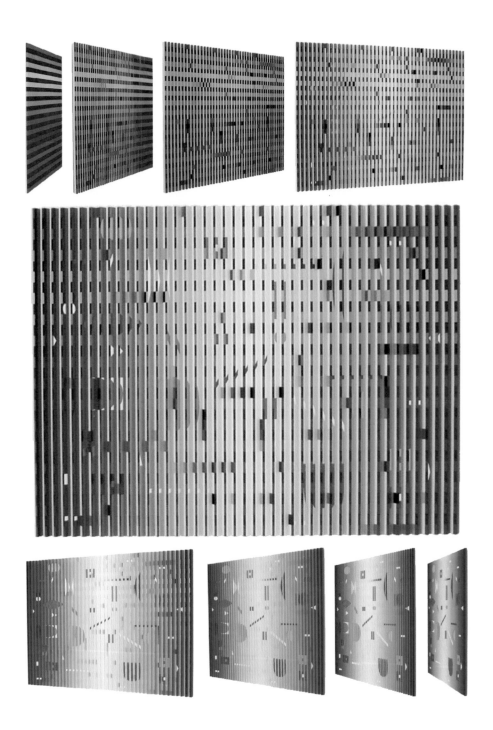

"Depth of the Sea," nine different views (1965–66)

Top: "Imagic Opera," polymorphic stained glass window and its mirror reflection,
at the entrance of the Spreckels Building, San Diego (1985)
Bottom: Agam in the workshop assembling "Imagic Opera" before its installation

"Jacob's Ladder," two different views: from below (top) and frontal view (bottom),
Residence of the President of Israel, Jerusalem (1970).
The mural rises to the whole height of the building.

*"Jacob's Ladder," ceiling mural, three different views,
National Convention House, Jerusalem (1964).
Visitors experience the painting changing at every step as they walk below it.*

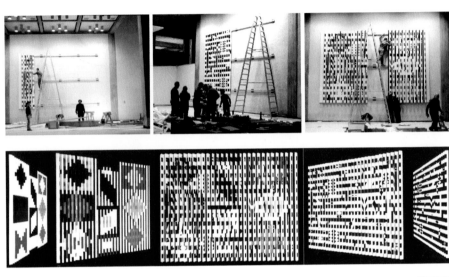

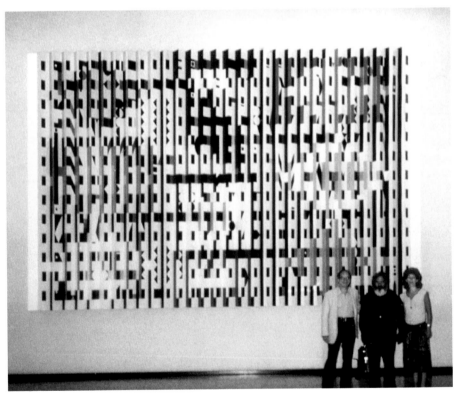

"Pace of Time," five different views, Tel Aviv Museum (1970).
Top: The mural being installed just before the Tel Aviv Museum inauguration
Bottom: The artist in front of the mural

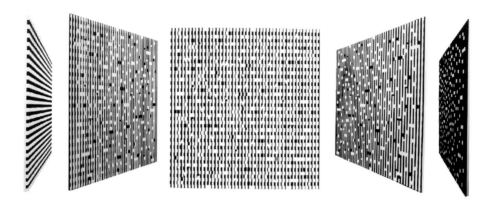

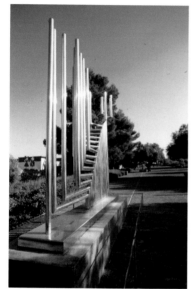

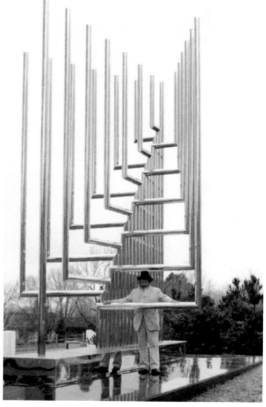

Top: "Staccato," five different views, Israel Museum, Jerusalem (1965)
Middle and bottom left: "Eighteen Levels," transformable sculpture, two different
views, Israel Museum, Jerusalem (1971)
Bottom right: "Eighteen Levels," Denver, Colorado (1987)

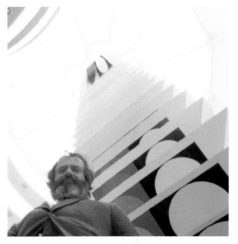

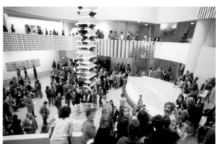

*Exhibition "Agam: Beyond the Visible" at the Solomon R. Guggenheim Museum,
New York (1980).
Middle left: Performing at the Guggenheim Museum a play specially written by
E. Ionesco for Agam's multi-stage theater*

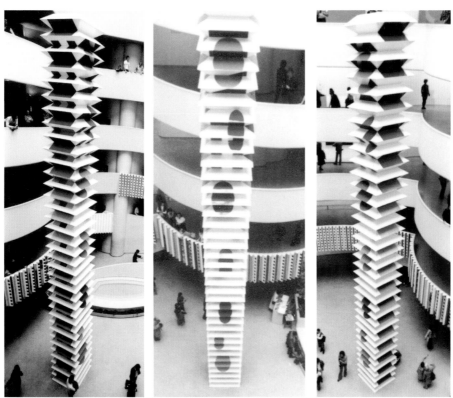

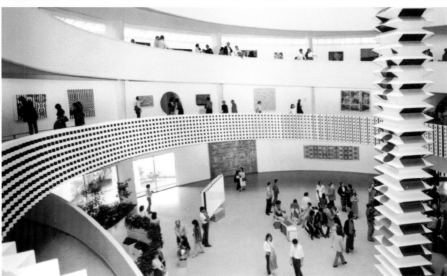

Exhibition "Agam: Beyond the Visible" at the Solomon R. Guggenheim Museum,
New York (1980)
Top: Multidimensional Tower, three different views

Retrospective exhibition "Yaacov Agam" at the Musée National d'Art Moderne, Paris (1972).
Bottom: Fire and Water Sculpture at the entrance of the Museum

Exhibition "Yaacov Agam" at the Museo Nacional de Bellas Artes, Buenos Aires (1996)
Middle: Diptych painting looking similar from the front and different from the sides

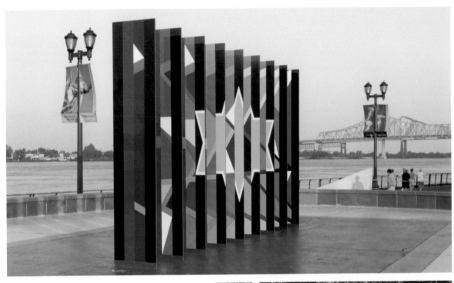

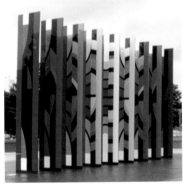
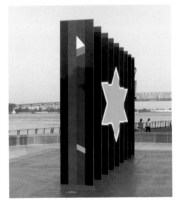

*Holocaust Memorial, six different views, waterfront promenade of the
Mississippi River, New Orleans (2002)*

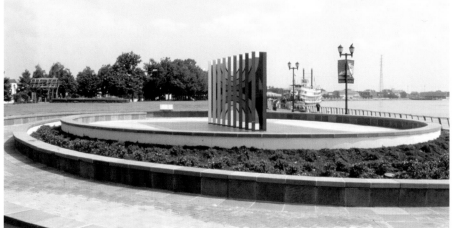

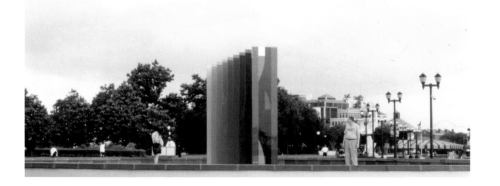

Holocaust Memorial, general view from the waterfront and from the garden, New Orleans (2002). The Memorial presents 18 different views illustrating the tragedy of the Holocaust and the hope of survival.

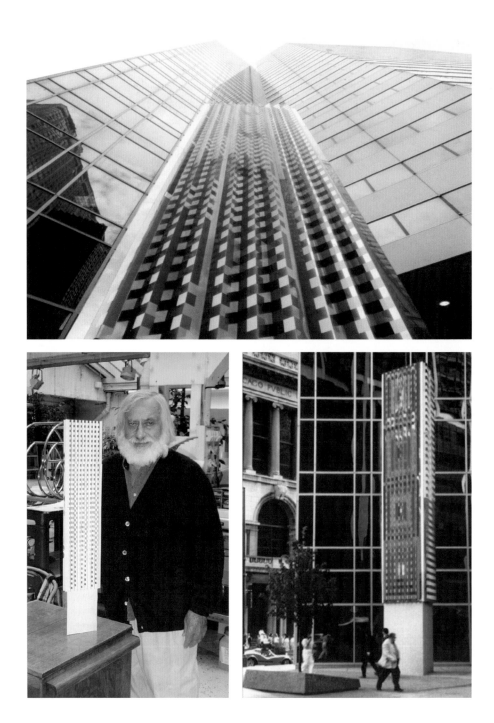

"Communication × 9," two different views, Randolph and Michigan Avenues, Chicago (1983) and its model with the artist

MONUMENTS

SADAT, BEGIN AND "STAR OF PEACE"

On November 19, 1977, Anwar El-Sadat's historic visit to Israel surprised the whole world. The visit of the Egyptian President dominated the headlines of world news for days as it represented a major breakthrough in the peace negotiations between Egypt and Israel. During his second visit to Israel in May 1979, a large and formal ceremony was held at Ben-Gurion University of the Negev in the south of the country, where the Prime Minister of Israel, Menachem Begin, and Sadat were presented with awards for their peace-making efforts.

Ben-Gurion University, located in the Negev (thus close to Egypt), had been involved in many cooperative projects with Egypt. Hence the university had closer ties with Egypt than other institutions. In 1977, when Ben-Gurion University had decided to establish the Ben-Gurion Award for an Outstanding

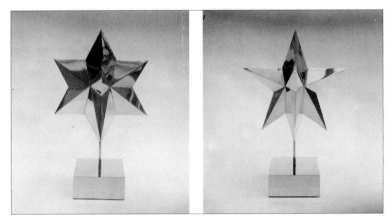

"Star of Peace" (two views)

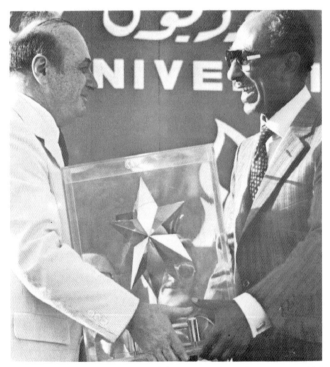

Yosef Tekoah presenting the "Star of Peace" to President Anwar El-Sadat

Contribution to Understanding Between the Peoples of the Middle East, the president of the university, Yosef Tekoah, asked Agam to create an appropriate art work to be presented to Sadat, Begin and President Jimmy Carter for their efforts that culminated in the Camp David Peace Accord. Agam responded with the "Star of Peace," which Tekoah described as a "magnificent expression" of the hope for peace. The sculpture was accepted, and copies were cast in Susses, France.

Actually, even before Sadat's visit, Agam had believed in the possibility and the necessity of creating an artistic image that would symbolize peaceful coexistence between Moslems and Jews. When Tekoah approached Agam, he created the sculpture which was structured in such a way that from one direction, the five-pointed star of Islam could be seen; from

"Star of Peace" presented to President Sadat and Prime Minister Begin (1979)

another the six-pointed star of the Jewish "Magen David" was visible; and from a third position the two stars appeared to fuse, creating a new star of peace and hope. "I made it so that no star would be bigger than the other," says Agam smiling. This work symbolizes the peaceful coexistence of two countries which were previously enemies – an ideal that looks like a faraway star in the sky.

Some time later, as they were traveling together from Camp David to Washington, D.C., Begin presented Sadat with a coin created by Agam, entitled "Star of Love." The Jewish star, the "Magen David," is representative of a shield. Wishing to rid the star of its militaristic association, he used the triangular figures of a man and a woman to form a star, as if to say, "let us make love, not war." On the other side of the coin, the Hebrew words for peace (*shalom*) and dream (*halom*) were fused.

Sadat, by being the first Arab leader to visit Israel, had already risked his life. He politely refused to accept any gift. However, being also a man of intuition, he visually understood the meaning of this piece with just one glance. He appreciated the gifts and messages they bore. The sculpture that was to have been given to Carter was presented to Reagan, since he was now the President of the United States. Agam personally presented the sculpture, and Reagan promised Agam that he would place the work in the Oval Room of the White House to signal the importance of peace in the Middle East. He was,

however, unable to keep his promise; since the law prohibits any changes being made to that room, not even the addition of a sculpture presented to the President on behalf of the American people may be added. Agam does not know the present whereabouts of his sculpture.

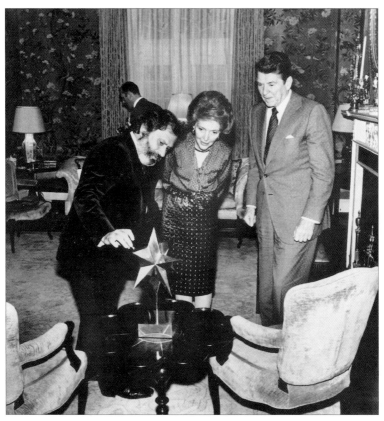

Agam showing "Star of Peace" to
President and Mrs. Reagan in Washington, D.C.

Agam has continued to make artistic contributions to the peace process. In 1994, one of his polymorphic works served as a peace award presented by the Director-General of UNESCO, Federico Mayor, to PLO Chairman Yasser Arafat, Israeli Prime Minister Yitzhak Rabin and Foreign Minister Shimon Peres. In this work, the Magen David can be seen from one angle and the star of Islam from another. They fuse to create a rainbow, the Biblical symbol of peace and hope.

Also in 1994, a polymorph was given to President Bill Clinton as an official gift from Israel, on which Rabin added the following statement: "Out of the light of the rainbow – the Biblical covenant of hope and peace to all living being, a new star is born – THE STAR OF PEACE. Fusion in harmony of two stars representing different civilizations. This artwork is presented to Mr. William Clinton, President of the United States of America and to the American people as a sign of gratitude for their contribution in making this event possible."

Agam with UNESCO Director-General Federico Mayor, Prime Minister Rabin, Chairman Arafat and Dr. Kissinger (1994)

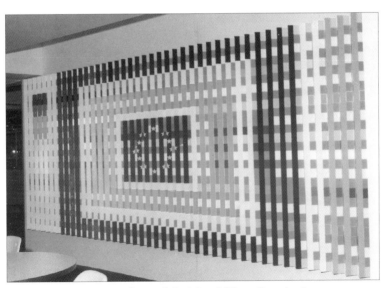

Above: Agam in front of the Mural "Peace" at the European Parliament, Strasbourg, at the inauguration of the building (1977) Below: The Mural "Life" at the European Parliament (1977)

"PEACE" FOR EUROPE

In 1977, Agam created two monumental mural paintings for the Parliament of Europe in Strasbourg.

One day, the President of the Israeli Knesset (parliament), Israel Ishayahu, telephoned Agam at his Paris studio and explained that a European parliament was being built, and that Israel wished to send a work of art by way of a gift to this important new international organization. (Israel is not a member country but has observer status.) Israel had already proposed several art works by prominent local and international artists, but thus far they had all been rejected. Restrictions applied as to what could be displayed in the building: there was to be no identification in the piece of art of the state that had presented the gift. Ishayahu asked Agam to create an art work which the Building Committee of the Parliament would be unable to reject, yet which would still be recognizable as a gift from Israel: "It would be good if they would accept a gift from the Israeli Parliament, even if it were placed in a small committee room. We appeal to your ingenuity and creativity to produce a nice art work with a beautiful concept that they will not be able to resist," said Ishayahu.

It was a difficult task and almost contradictory in nature. Agam created two small models of polymorph paintings. In one, entitled "Peace," the flags of the democratic nations of Europe joined to produce a rainbow; in the other, entitled "Life," a design symbolizing all the activities of life – culture,

industry, agriculture, science and art – transformed to create one image: the flag of Europe.

These models were received with great enthusiasm by the architect and advisory committee of the European Parliament. The architect said that he had been searching long and hard for an artistic idea to express the unity of Europe, and was delighted finally to have found one in Agam's project. Instead of placing the paintings in a small, out-of-the-way meeting room (originally designated as the site for the Israeli gift), the paintings were to be hung in the entrance, opposite the main hemisphere room.

Before the murals were sent to Strasbourg, a delegation, consisting of the General Secretary and representatives from the United Kingdom, Italy, Austria, and other states, was sent by the advisory committee to view the work in the artist's studio and check that there were no visible identifications of Judaism or Israel. Agam had written in large Hebrew letters the word *shalom*, meaning peace on one work, and on the other *chai*, meaning life. On the polymorphic, multi-dimensional art work, these could be seen only from a certain angle. As none of the delegates could read Hebrew, they simply considered the Hebrew letters as abstract decorative designs and the works were accepted.

Thus, installed in the building were the two huge mural paintings "Peace" and "Life." They were oil on aluminum reliefs, each with a height of 5' 11" and a width of 16' 4". The works were polymorphic, made up of triangular pillars, the

images on which transformed as the viewer stood at different angles of viewing. In the work "Peace," for example, from one angle, the flags of the member nations of the European Community which have three colored stripes (such as France, Germany, Holland and Italy) could be seen, and from another the flags with crosses (such as England, Denmark and Sweden) came into view. As the viewpoint shifted, the flags slowly mingled together to become united in one image: that of the rainbow, which represents peace and the hope of unity.

Not wanting it to be rejected on the basis of the Hebrew lettering, Agam installed his artwork the night before the inauguration of the building. The following morning, at the reception, everyone was happy with the murals, marvelling as each of their respective flags came into view. When a journalist from the Jewish weekly published in Strasbourg (who could read Hebrew) discovered the Hebrew word and began to call out: "Oh, it's *shalom*, it's *shalom*," Agam feared a scandal would erupt. At the same moment, however, a leading politician, Alain Poher, President of the French Senate, entered the building, was much impressed by the mural, congratulated Agam and openly embraced him, saying, "Now, a united Europe is no longer a dream but a reality." (Fittingly, dream in Hebrew is *halom*. *Shalom* is no longer a *halom*.)

Agam's second mural, "Life," was installed on the wall opposite "Peace." Thus it came about that senators, ministers and visitors to the Parliament of Europe enter only by passing through the two gifts presented by the Israeli Parliament.

"TOUCH ME" PROJECT

The work Agam created for Le Quartier de la Defense in Paris is worthy of discussion. La Defense, with its many skyscrapers, is located on the extended line of the Champs d'Elysée, and thus forms part of the "Triumphal Axis" of the city, which begins at the Palais du Louvre, includes Place de la Concorde, Obélisque, Arc de Triomphe and ends at the new Grande Arche of La Defense. In its central plaza, people lunch in the cafés, lie on the lawns, or look at the sculptures of Joan Miró and Alexander Calder. Agam's fountain is installed in the center of the plaza. It is replete with 66 vertical water-jets and 5 multi-tulip-flowered water jets which, under the control of a computer, seemingly respond to music. The mosaic pool is 160 feet long and 75 feet wide. On its backside walls is a polymorphic mosaic surface of 90 different colors on which there is a wide waterfall.

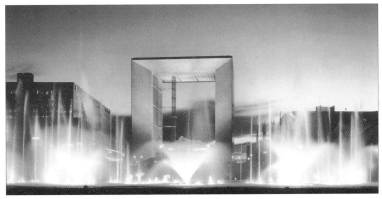

Agam's Monumental Fountain at La Defense complex, Paris (1975)

Triumphal Axis

The fountain is characteristic of Agam in two ways. First, rather than alienating people, it invites people in the area to approach it. When one considers that kinetic art truly exists only when it includes the participation of an audience, then the plaza provides an ideal setting for Agam's work to "operate." Secondly, the work bears Agam's stamp in its use of advanced technology. Unlike other cultural sites in Paris which memorialize historical events, La Defense looks toward the twenty-first century. Agam's fountain features streams of water from which distinct tulip shapes evolve. "These 'tulip jets' look like ballerinas on an immense stage, with 66 vertical jets dancing in the back," suggests Agam amusingly. Music accompanies the fountain. Fire was also to be used in combination with the water. At the official inauguration, in the presence of the French Minister of Culture, Jean Philippe Lecat, fire sprouted from the water jets, but unfortunately, due to concerns about the use of energy during the oil crisis, this has not continued to take place. Since its inauguration in 1975, Agam has continued to revitalize the work, using advances in computer technology. This is in accordance with his notion of art as a living thing.

Agam also received a commission from the Director General of La Defense, J. Millet, to create an environmental sculpture entitled "Touch Me." This is to be a huge, outdoor, transformable sculpture (twelve meters high)[1] whose form will have a graceful simplicity, thus welcoming the viewer. A small version of the same work will be placed nearby. People will be able to touch the miniature and, through the use of computers inside both sculptures, the huge original would move in response to these touches. In this way, people would be able to participate in the ongoing *re-creation* of the sculpture and have some control over the entire plaza. Agam would like to connect the miniature with huge sculptures in Tokyo and New York which would similarly respond to the touch of a person

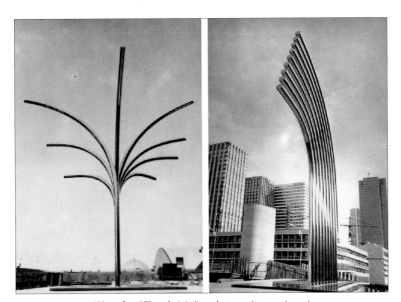

Plan for "Touch Me" sculpture (two views)

standing in Paris. "I already have a subtitle in mind," says Agam, "'Communication x 18.' This sculpture would give each of the participants the liberty and joy of creation. The possibility of creation should exist for all, not just for a handful of artists. After all, do you think that the Second Commandment prohibiting the making of graven images was given just with artists in mind? This is impossible! The Commandment was given to all of humanity, for God bestowed the gift of creativity upon all."

Note

1. Agam originally planned to create a six meter high sculpture. The organizers wanted to have one nine meters high, then a twelve meter one. Then, for technical reasons, the stainless steel tubes of this size had to be produced in Germany, and money for this was actually paid to the German company in French Francs by the French company. However, the German company prefered to be paid in German Marcs and sent the cheque back. In the mentime, the French company unfortunately went bankrupt, thereby bringing the project to a deadlock for the time being.

AGAM AND JEWISH ART

"THE THREAD OF LIFE" AND THE RAINBOW

When I organized the retrospective exhibition "Agam: Father of Kinetic Art," held in several Japanese museums in 1989, only one of the eighty exhibits was from a Japanese collection. The piece was titled "Le Fil de la Vie" ("The Thread of Life"). It was made in 1970 and purchased in 1980, before Agam became well known in Japan, by a pioneer collector of contemporary art, Toshio Hara. It belongs to the Hara Museum in Tokyo, where he is the Director.

"The Thread of Life" features a long colorful thread (similar in look to the traditional Japanese sash band) which emerges from a transparent acrylic box. One can pull the thread out of the box in which it is neatly folded, thereby creating a multi-colored canvas; but once pulled out, it can never be returned to the box – just as life lived can never be reversed or re-lived. The work accords with Japanese notions of the

transience and frailty of human life. Frank Popper's book, *Agam* (Harry N. Abrams, 1990, New York, which the author translated into Japanese), features a photograph of someone cutting the thread of this work with a pair of scissors. Indeed, when confronted by this work and its title, "The Thread of Life," a person is made to feel as if he or she is in a situation of control.

As in so many of Agam's works, this one features the colors of the rainbow. I asked Agam about this rainbow motif. "Perhaps you know the story of Noah and the Biblical flood?" Agam asked by way of reply and then continued: "God, disappointed with the corruption and vice of humanity, determined to destroy it in a flood. With the exception of Noah – a righteous man, his family, and a pair of each of the animals, the world's population was to be drowned by the waters which would flood the earth. According to the *Midrash* (a compilation of homilies, Biblical exegesis, and sermons), Noah attempted to negotiate with God in order to save as many lives as possible. In the end, the rain poured down for forty days and forty nights, and it covered the earth."

"This was a holocaust," continues Agam. "The holocaust experienced by the Jews in Nazi concentration camps, and the catastrophe which fell upon the Japanese when atomic bombs hit Hiroshima and Nagasaki are minor in comparison with this Biblical holocaust in which all people, their cultures and civilizations were destroyed."

As a Japanese woman, the author was astonished by the way Agam spoke. With such a realistic and personal narration, it was as if the Biblical flood had taken place just two or three generations ago. Perhaps this way of relating to the distant past is attributable to the sense of history held by the Jews; it has been said that this people lives "in the course of history." In Agam's mind, history is there, *visualized*, and he only has to describe it with these simple words.

Agam continued to describe the flood: "Noah's ark was rolling and pitching on the surface of the water. When the tempest subsided and the water began to recede, Noah's dismal melancholia still remained. One day, a dove that Noah had released earlier returned with an olive branch, proof that the water level was dropping. (This is the origin of the olive branch's association with hope and peace.) But when God ordered Noah to disembark, do you think he got off the ark eagerly?" asks Agam. (All the while that Agam was narrating, he was drawing visual explanations with a Japanese jet-black brush pen.)

"If you think so, you are naive," says Agam. "Having looked out of the open door, Noah slammed it shut. Why? Because he, who had experienced the end of the world, who had seen too much, had no desire to start all over again, only to have everything once again destroyed. Instead of just walking out, Noah negotiated with God. The two finally came to an agreement: as long as the Covenant is wisely kept, the world

would never again be destroyed; and a rainbow sealed the agreement." This is such a quintessentially Jewish story: bargaining even with God, getting a pledge, and demanding clarifications in the agreement.

"This agreement was not verbal," emphasized Agam, "rather it was written in a *visual language*. That was a rainbow, an expression of light and multicolored arches, like an imaginary gate. Many of my works carry these rainbow colors as a means of perpetuating the Covenant between you, me, everyone, and God. After all, the promise God made was not a personal one to Noah but to all living creatures, including all the generations to come." How interesting the "Agam Midrash" is, the author thought.

The rainbow comes about by light refracted and reflected by raindrops which divide the light into the spectrum of seven colors which are visible to the human eye. What we see is the "result of the movement of light"; but the light itself, the essential quality that exists behind the rainbow, is never visible to us. It seems to the auther that the rainbow is emblematic of Agam's work: his effort to disclose (or suggest) an invisible reality through the movement of art and the participation of the viewer.

HEBRAIC CONCEPT OF GOD

The motive behind Agam's work as a whole is his ambition to represent in a visual, plastic form the concept of reality of ancient Hebraism. (We must note here that he does not use the term "Judaism," but rather "ancient Hebraism.") The key to the difference between Agam's work and the works of other artists does not lie in forms or technique, nor in modes of presentation either. All artists are influenced in some way (regardless of whether they like it or not, or whether they are aware of it or not) by the time in which they live, and by the technological advances of the time, an influence which is unavoidable. However, when Agam says that, in his work, things invisible are more important than things visible, we must make our way to the world of the Torah (Bible) to understand what he means. For the concept of the God of the ancient Hebrews and their perception of *reality* forms the basis for Agam's work.

One of the most basic elements of ancient Hebraic beliefs, stated in the Ten Commandments of Moses, is the command "You shall not make for yourself a graven image." This prohibition against graven images was, in fact, exceptional in the ancient world of a few thousand years ago. For people of that time needed something – the Sun, the Moon, the stars, sacred stones, living gods – to pray to and to worship. However, the Hebrew people were unique in their stubborn

rejection of that idea, and they sometimes even lost their lives by that rejection. In the end, what divided Jews from non-Jews has been their refusal to worship idols, and their refusal to worship or serve any god other than the invisible, unimaginable, unnamable Hebrew God.

The first question, then, is "what is a graven image?" Agam defines a graven image as a "static image." "There is no life in a static image, which Judaism despises and rejects (as a kind of *idol*), never accepting a graven image even as a form to represent reality. It does not represent reality, because the most remarkable characteristic of reality is that it is always *becoming*," argues Agam.

Here all of Agam's creative activities begin. All of the everyday phenomena of constantly changing reality take place in the realm of the fourth dimension of time. This is what Agam seeks to incorporate in his art, and it makes his art original. Hebraism itself is different from all other civilizations and religions in its realization that reality takes place in the fourth dimension. Here we might recall that the Kabbalah, the book of Jewish mysticism, mentions as many as ten dimensions. It distinguishes Hebraism from many other cultures which have expressed "what already existed in the past" with their idols and statues, thus "freezing time forever" in their paintings and sculptures – in their graven images.

In fact, not all cultures accept the passage of time. Some attempt to defy time, and lock the past into history: "Men were afraid of death, so they tried to fight time. For example, kings, pharaohs, men of power resist time for they see it as depriving them of wealth, power, glory, and, of course, life. Time is their biggest enemy and they try to overcome it. The building of the pyramids provides an excellent example of this impulse to confine and defy time and control reality. Artists, too, attempt to defy time when they draw static objects, thereby fixing them in time. This is a 'graven image'," argues Agam.

"To defy time is to position time as the adversary, to struggle with its power in an effort to negate it. But time is more powerful than the most powerful man. This is why great men and artists have tried to fight time, and eliminate it. In many civilizations, people *intentionally* reject the factor of time: they recognize *continuity* in time, but deny, or even ignore, the factor of time. They hang paintings, which never change, on their walls as if to say that nothing is really changing in the world. In this respect, the ancient Hebrews were very different from those around them. They did not attempt to define time or fix it in images. For them it was out of the question to express visually 'what is the Almighty' or 'what is reality' because these are invisible and constantly changing." Thus does Agam explain the ancient Hebrew prohibition against graven images.

"Everything in life changes," insists Agam. "A man is born, he grows and then dies. Art does not accept this; it seeks to represent eternity. Such art is a 'graven image' because it attempts to confine, define, and stop time."

Just as the making of graven images and the worship of idols were prohibited, so too was it forbidden in Judaism to think of the world as fixed and engraved. It forms a sharp contrast to other religions: The ancient Greeks, the Hindus, Christians, and Buddhists have all constructed elaborate shrines, temples and churches and decorated them with statues and works of art. They did not want to admit that there *is* a power that transcends those constructions – "Time." (Moslems are a rare exception because they, like Jews, prohibit the making of graven images and allow only abstract decoration in their mosques.)

Strictly speaking, however, even the ancient Hebrews did not always avoid graven images. As we see in the story of the "Exodus," while the Hebrew people were left alone at the foot of Mount Sinai for forty days while, on the mountain itself, Moses was facing God alone to receive the Law, they felt abandoned, and did not know what to do. So they collected all the gold and jewelry from their women. They then made a golden calf out of it and danced around it. Why did they do this? Why did they disobey the commandments received from God through Moses? Didn't they vow to abandon idols and revere only God Almighty? I think it was the result of human

nature. For too long the Hebrew people, during their sojourn in Egypt (for four-hundred and thirty years, according to the Bible: *Exodus* 12:40), had been exposed and accustomed to physical *shapes* and *forms*, like the golden calf, as objects of worship.

Here the golden calf represents symbolically the graven image, the symbol of rebellion against and opposition to (indeed, the negation of) the Hebraic approach to life and reality. It is no wonder then that when Moses came down from the mountain he became furious, broke the golden calf into pieces, and threw them into the fire. (The description in the Bible of his breaking the calf is truly frightening: After breaking the calf into pieces and melting them down, Moses made the Israelites drink the liquid. He also ordered the Levites to slaughter three thousand people by the sword, for the people had exposed themselves "to their shame among their enemies." It was, in fact, the *execution* of those who had rejected the *ideology* of "believing in the Hebrew God." For in the Jewish way of thinking, reality is beyond the visible, is not a graven entity, and the Almighty God should also be unfathomable and invisible. Therefore, it should be impossible either to express existence of God as a human figure, or to express it in any form.

Indeed, the history of the Jewish people related in the Bible is at the same time an account and a prophesy of these contradictory ideologies and values. There are contradictions

between God who prohibits His "chosen people" from idol worship and His people who sometimes strayed from the path of righteousness. The Bible also tells of the prophets and *tzaddikim* (righteous ones) who scolded and encouraged the people. It relates the story of political interference and oppression, as well as the military pressures and invasions by the more powerful neighbors of Israel (such as the Assyrians, the Babylonians, and so on). Indeed, Jewish history is the story of the vicissitudes of this people, of the cycles of victory and destruction, of exile and return. However, the Jews stubbornly survived all of this *as a nation*, for five thousand years, without disappearing into *the sea of nations*. Throughout these five thousand years, even as they spread all over the world in the Diaspora, the relation with God and the struggle with these contradictions defined Jewish existence.

UNNAMABLE GOD

In a town called Yavne, in Israel, the author first saw Agam's kinetic sculpture entitled "Roots." The history of the town itself gives some indication of the roots with which Agam is working. In 70 A.D., the Jewish War against the Roman Empire was about to end. Facing within a few days' time the siege of Jerusalem, and the concomitant destruction of the Temple and of the Jewish State, a rabbi escaped from the city of Jerusalem, and broke through the enemy lines. His name

was Rabbi Yohanan ben Zakkai. He managed to escape by disguising himself as a corpse, and having his disciples carry his coffin toward the burial ground outside the city. He had to deceive the eyes not only of the besieging Roman soldiers, but also of the *zealots* who were tightening their hold, and terrifying people by saying, "Nobody is allowed to get away from Jerusalem alive."

Before escaping, Rabbi Yohanan ben Zakkai had communicated with the commander-in-chief of the Roman army, General Titus, who was later to become Caesar (Roman Emperor), and had requested permission to open a school in Yavne, following the inevitable destruction of the Temple and the Jewish nation. Titus, clearly unaware of the historical

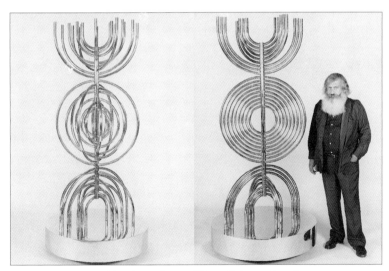

Kinetic sculpture "Roots" (two views)

significance of this old man's modest request, acceded. About the same time that Rabbi Yohanan ben Zakkai established a yeshivah in Yavne, the Romans were plundering the city of Jerusalem and murdering between 600,000 and one million of its unarmed inhabitants. The Temple was destroyed.

Escape from the besieged Jerusalem in order to open a yeshivah was an imperative decision of Rabbi Yohanan ben Zakkai, for he was afraid that the study and tradition of Judaism might cease after the destruction of the Temple. History has proven that his founding of the yeshivah made a greater contribution than one can imagine to the survival of the Jewish people *as a nation*. The spiritual power that sustained the people throughout the history of the Diaspora, after the destruction of the Jewish state, is rooted here in Yavne, because the continuation of the religious and the scholarly tradition was initiated here.

The work "Roots" has three parts. Agam explains, "the lowest part of the sculpture is mostly fixed, representing the material 'fixed' past, whereas the upper part is open and capable of movement, representing the spiritual hopes and possibilities of the future."

"Is the middle part then representative of present daily life, which takes place between the material and the spiritual in dynamic form?" asked this author.

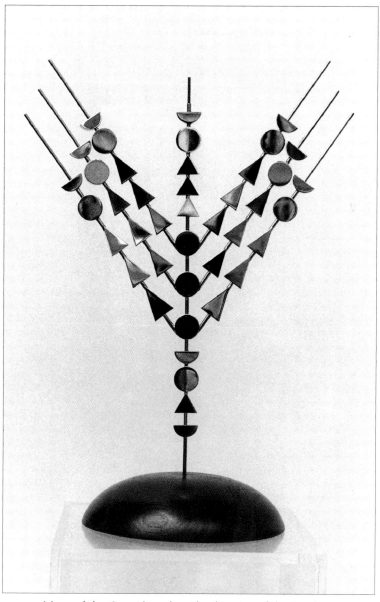

Menorah by Agam based on the drawing of the Rambam

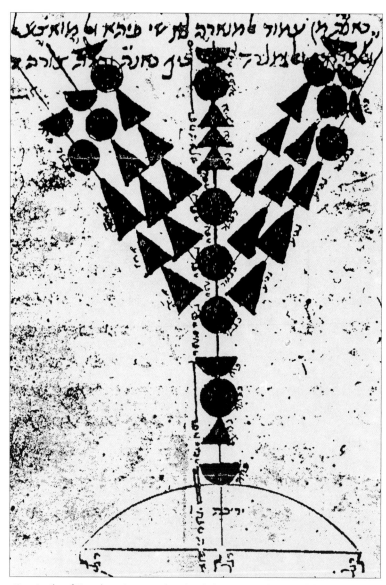

Facsimile of Rambam's own sketch of the Menorah (candelabra) in the Bet Hamikdash

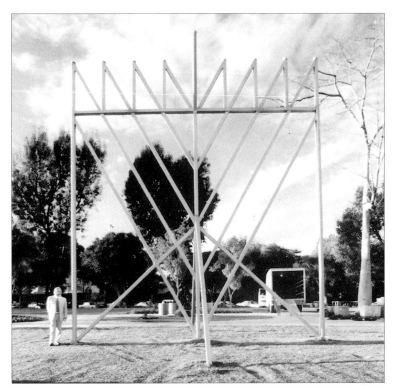

Menorah by Agam (Beverly Hills, CA) is inspired by the drawing of the Rambam which differs from the traditional curve design which appears on the Titus' monument of triumph in Rome

Agam's answer was complex and profound. He spoke of the holy nature of time in the Jewish tradition. He explained that in Hebrew, the word for "present" is *hoveh* הווה, past is *haya* היה, and future is *yiheyeh* יהיה. They look similar if you write them in Hebrew. The letters which make up those words are the same letters that make up God's unpronounceable name: *yud, hey, vav, hey* י,ה,ו,ה. It is forbidden, as stated in the

Third Commandment, to pronounce or even write God's actual name, except in very limited circumstances. (In the Hebrew language all letters are consonants; therefore, if you do not put *nikkud* (vowelization), you will not know how to pronounce the written words.) In fact, so rarely have circumstances warranted the enunciation of God's name that the correct way of pronouncing it has been lost to history. (*Jehovah* is most commonly used, though, as denomination.) In order to address God, Jews use various other words, such as *adonai* or *elohim* (interestingly, a word in plural form) which refer to notions of God rather than God's name. One does not vocalize the name, but just looking at it brings the suggestion of understanding God's place and power: God's name encompasses each of the temporal dimensions of past, present and future. Agam believes that notion of God "does not embody a certain form or a given time but rather is in a state of constant becoming, with transformative power."

This notion of "constant becoming" is fundamental to Agam's work. As the concept of God is beyong human knowledge, is unimaginable and unthinkable, and (as it is unnamable) cannot be defined by anything; it becomes impossible to capture God's reality in static form. We can only get a glimpse of this changing, non-static reality of God, and only within the context of the idea of *constant becoming*. The second and third dimensions do not adequately express this reality. We can feel such "reality" in the fourth dimension,

where things appear and disappear at every moment, in a process of transformation.

However, Agam cautions against simplifying the terms of the name of God, since it should not be made too distinct that "the name of God (yud, hey, vav, hey י,ה,ו,ה) includes the past, the present, and the future." He continues in this vein: "This interpretation of 'yud, heh, vav, heh' is very ambiguous, so that such an interpretation as mine should be considered as one suggestion only. Because God is a mystery."

Agam goes on to explain that "the name Jehovah is a 'grammatical term' which evokes the constant change and becoming – one way to *approach reality*. For, as the words (which consists of the letters 'yud' י, 'heh' ה, and 'vav' ו) are rather similar in form, the word 'Jehovah' might have the implication of, and links to, three different time zones – that is, past, present, and future – and, at the same time, it is defined as none of them, and it cannot be grasped. Thus it is very ambiguous. God is a mystery; for God is in a *dimension beyond*." Agam links this uncertainty in the word "Jehovah" to other examples of the Hebrew way of thinking. He explains that "you cannot imagine the essence of Life, if it is not given the precondition that Life depends on a very limited idea. In the Hebrew language, in its grammatical forms, we use expressions which are not static. We don't use expressions to eternalize something, but rather we use expressions which are in the state of constant becoming. If this is a grammatical

characteristic entirely unique to the Hebrew language, then it must be the 'Hebrew way of thinking' or 'Hebraic ideas' that lie behind the language itself, I believe."

In this sense, Agam's interpretation of the concepts "yud, heh, vav, heh" speaks to the basis of the Hebraic view of life, and understanding of God.

(His hypotheses, which include ideas of fragility and change, strike a chord with this author, for they are also important notions in Japanese culture and, especially, aesthetics.)

These abstract ideas are explored in plastic form in Agam's art. Whereas visual art has traditionally seen as its aim the eternalization of events or moments that have taken place, Agam seeks to include in his work elements of the unknowable, the unexpected, and the unforeseeable. His works exist not only in the realm of space but also in time. Time moves, it "flies," and things change, adopt new shapes and forms, creating new *situations* and possibilities. Only then do the viewers find themselves facing different possibilities to choose from, challenging the limit of possibilities in the process of becoming; in this way they are integrated into the artistic situation. This is what Agam presents to his viewers with in his art, which is constantly becoming – a challenge to traditional modes of perception.

LIKENESS OF GOD – REVELATION TO CREATIVITY

A person sometimes wishes that time would stand still, particularly at happy moments. Time, however, never stops, it flows continuously.

The words "Memento mori," appearing with a skull in paintings of the Middle Ages when pestilence was rampant, remind everyone that it is their fate to die. These paintings hint at the passage of time yet they never contain the element of time within themselves. Later, Edgar Degas drew the shapes of galloping horses, and was very enthusiastic about photography (in his day, a new and advanced technology) because of his interest in depicting the passage of time. The

"The Dynamism of a Dog on a Leash"
by Giacomo Balla

futurist painter, Giacomo Balla, created an important painting, "The Dynamism of a Dog on a Leash," which shows the movement of a dog's feet and tail, the shaking of a leash, and the flurry of a woman's feet (since he was focusing on movement, he did not draw the whole figure of the woman). Artists of the Cubist movement sought to transcend the limitations of seeing one image at a time. They would draw one face from different angles in a single portrait in an effort to represent multiple visual experiences which the viewer could have only on more than one occasion. Picasso's portrait of a young woman is emblematic of this style: both sides of a profile can be seen at once. However, it was simply the co-existence of several images, "fixed" in a series of different timings.

Agam discusses Leonardo da Vinci's art: "I understand what his intention was. The eyes of the Mona Lisa follow you as you move in front of the painting. And her lips – almost a smile but not quite: The artist was about to draw the smile but dared not do that. You can see *the intention* to smile, but you cannot catch it. Such an ungraspable reality is what Leonardo introduced into art with his painting of the 'Mona Lisa'." Agam speaks of Rembrandt also as a *kinetician*. "Rembrandt used the effects of light to create a sense of time in his works. The viewer first sees a scene dramatized by strong light, his eyes then move to the weaker light, and finally to the

shadows, where images appear in the darkness, thus following the time sequence of the story of the painting," explains Agam.

For Agam, art is a tool for creation. Therefore, art for art's sake is out of the question for him, and he despises the impulse to repeat the same thing over again. The diversity of his artistic activities, the breadth of genres in which he works, attest to his intense search for creation. His art cannot easily be placed in a particular school. Some art critics have tried to define him, calling him an abstract artist, while others try to relate him to hard-edged artists such as Josef Albers and Max Bill; others argue that he was influenced by the Bauhaus through his teacher Johannes Itten, or, as a kinetic artist, Agam has been discussed in relation to pioneer artists of this genre, such as Marcel Duchamp and Alexander Calder. He has also been compared (but not related) to the Op artists. Most generally, he is considered one of the pioneers of contemporary kinetic art, together with Jean Tinguely, J.R.Soto, Pol Bury, etc. To classify artists, however, is something of a fruitless task, especially when dealing with an artist whose approach is so diverse as Agam's. There is always an aspect of his work which exceeds all established categories. Many artists have a "gray zone," which makes placement into particular schools difficult. Agam is an artist who has an interdisciplinary approach, in a real sense.

"Art has no beginning and no end ... like the rainbow and like life; it has no goal (if it has, it is stagnation). Rather, it

continues to create," says Agam. "Furthermore, that suggests the vitality and continuity of creativity, which are characteristics of human beings. It is written in the Bible that humans were created in the image of God. How? Why? The artist who copies is more like a monkey than like God. God Himself is, first of all, the supreme Creator, and when people are creative, then they are demonstrating a *likeness to God.*" This is why Agam encourages viewers' participation in the *life* of an art work: through this process, art is constantly being created anew.

LOOKING INTO THE FUTURE

VISUAL LANGUAGE

One of Agam's most outstanding contributions (outside of art) is the creation of a visual language educational program, which begins with children at the preschool level and can continue throughout life.

The Agam Method allows children to learn, step by step, how to discriminate the different levels of form and color in space and time. Using a visual alphabet, made up of simple forms, to construct and remember visually, children develop the capacity to see the dynamics of form itself, and the relations between one form and another. Seeing sensitivity is enhanced in three ways: through understanding visually, remembering visually, and reconstructing visually.

The program devised by Agam is based on a particular understanding of children's intelligence: "Children have their own visual memorization capacity that they are born with.

Their ability to see and to understand visually comes as naturally to them as the acquisition of the mother tongue. When one tries, however, to give children 'early education' –cramming their minds with letters, names, over-verbalizing everything – then the capacity for 'visual understanding' is weakened. Once lost, it is difficult to recover this visual capacity," explains Agam.

"I wrote thirty-six booklets, manuals which teach the 'alphabet' of visual language," explains Agam. The program was devised by Agam in conjunction with the science teaching department of the Weizmann Institute of Science in Israel. The aim was to help young people develop their "visual thinking" as a means of improving their overall cognitive development. The effectiveness of the Agam Method, with its innovative curriculum, is evaluated by the center.

A test was given to two groups (one consisting of students who had participated in Agam's visual education program, and one consisting of students who had not). The results "demonstrated that the children in the experimental classes performed significantly better than the children in the comparison classes on tests measuring basic visual concepts and skills" (B. Eylon and S. Rosenfeld, *The Agam Project*, Weizmann Institute of Science, Israel). It is interesting that, although the program is aimed specifically at enhancing competence in the visual field, the research indicated that children trained in the program demonstrated significant

Agam with young students in "Agam Method" visual education class in Rehovot, Israel

improvement in tests measuring general intelligence and mathematical readiness as well. This finding suggests that the visual education program created a positive attitude toward other fields of study.

In Israel, the Agam Method is used in hundreds of private kindergartens (for 3-6 year olds), elementary schools (for 5-8 year olds), and in 50 after-school centers. Thousands of children from Golan in the north to Eilat in the south participate in the program. Israel's Ministry of Education introduced the method to kindergartens around the country starting in September 1995. Israel puts much effort into educating its population because "humans are the greatest

assets Israel has," says Agam with a smile. (This position arouses sympathy amongst Japanese people because Israel and Japan share similarities: Both countries are small with limited natural resources, and their children are their greatest asset. That is why the Japanese are hard-working and do not spare any expense on their children's education, generally speaking.) The Jewish Community Center of Greater Palm Beach, Florida, used the program, and in Venezuela, due to the efforts of the then Minister for Development of Human Intelligence, Dr. Louis Alberto Machado, the program was once adopted for visual education in pre-schools there.

The development of visual sensitivity leads to improvements in other fields. For example, children with verbal difficulties may perform well in visual language classes. This achievement gives them confidence and pride, motivating them to gain mastery in other areas. The program works well in immigrant societies, such as Israel, where many children have parents who do not speak the local language fluently. As they are not exposed to sophisticated verbal communication at home, these children tend to be rather passive in class, and consequently are seen as underdeveloped by their teachers. Using a visual language gives these children confidence, promoting enthusiasm for other forms of communication.

In October, 1996, Agam, represented by the State of Israel, was awarded the Jan Amos Comenius Medal 1996 from the United Nations Educational, Scientific and Cultural Organization (UNESCO) "for having devised a particularly effective method of visual teaching for children." In the

awarding ceremony, held on an occasion of the 45th International Conference on Education at the International Conference Centre in Geneva on October 4, 1996, it was stated that they awarded him the medal "for the proven educational efficiency of his method, tested over a period of eight years - 1983 to 1991 - by the Weizmann Scientific Institute in Israel. The resulting programme has not only demonstrated an improvement of visual skills among children, but also in their intelligence, particularly in the areas of writing and arithmetic. The programme is especially useful for children coming from different social, economic and cultural origins. Already applied in schools for infants in Israel, this approach and programme can be introduced in any country for they use a strictly visual and universal language." The medal and a diploma was presented by Colin Power, UNESCO Assistant Director General for Education on behalf of UNESCO Director-General Federico Mayor, and by Emanuel Ondracek, Czech Republic Vice Minister of Education, Youth and Sports.

The Comenius medal, awarded every two years, was created in 1992 jointly by the Ministry for National Education, Youth and Sport of the Czech Republic and UNESCO, with an intention to reward outstanding achievements in the field of educational research and innovation. Commemorating the spiritual heritage of Czech pedagogist Jan Amos Komenský (1592-1670), its principal aim is to promote and encourage new initiatives making a significant contribution to the development and renewal of education.[1]

Visual training need not be applied only to children. In Japan, for example, at the Nippon Wilson Learning, a school which trains people at management level, the Agam Method is used to enhance the creative thinking of business executives.

Verbal language dominates people from childhood, even from infancy, and over-verbalization has the effect of suppressing visual capacity. Most people, when looking at a work of art, for example, will think of the meaning of the image in terms of verbal notions rather than responding to the work visually – a process of *translation* occurs. This is because they have been trained to think verbally rather than visually. It is necessary to liberate and develop visual sensitivity, thus allowing creative abilities to flourish. This is the essence of Agam's visual education. Through a visual alphabet and visual grammar, people develop the capacity to store and recall visual information, to read, and even to think, visually. Agam's art work has a similar aim: color formations and transformations of form spark in viewers an awareness of their own visual reading capacities.

Agam's interest in Japan derives in part from his interest in visual education. He wonders whether the Japanese are more trained visually than Westerners due to the complex letters and characters they use to communicate. Whereas Westerners use letters which are only phonetic signs, the Japanese use, even on a daily basis, thousands of ideographs, which indicate both sounds and concepts.

"Japanese people have a sense of curiosity. They like innovation and surprise. And they are very sensitive to form," says Agam. "Perhaps this developed visual curiosity originates in the use of Chinese lettering, which is complex in visual form, and constantly develops and evolves. The use of these letters requires a great deal of imagination, for one must observe the meaning of letters and words and be sensitive to the spiritual process involved in their creation. Latin letters, on the other hand, evoke phonetic sounds; they are static in this sense."

Japanese viewers do react in particular ways to art, and perhaps this is connected with their visual education. Japanese tend to prefer asymmetry to symmetry, and fragile, sensitive beauty to strong, static constructions. It came as something of a surprise that there should be commonalities between the Japanese aesthetic sensitivity and the ideas of an artist like Agam whose intuition is so strongly rooted in his Jewish background.

Notes

1. Jan Amos Komenský (1592-1670), born in Moravia, developed the philosophy of pansophism and was a major figure in the humanistic tradition of education. As a member of the Moravian Brethren (a Protestant sect), he became a refugee after the onset of the Thirty Years War and subsequent persecution by the Hapsburg Dynasty (which was Catholic). Out of suffering from the cruelties of his time was born the philosophy that emphasized political unity, religious reconciliation, and educational cooperation. This philosophy of pansophism presented the goal of education as the development of universal knowledge among all people and all nations. He envisaged educated people as those who sought knowledge from all sources "in order to become more like the God in Whose image they were made." As Václav Havel mentioned in his speech on an occasion of a conference on Komenský in Prague in March, 1992, Komenský "sees the only possible source of external improvement in human intellectuality and spirituality, in meditation, and in a humble relationship to the act of creation. ... For him, all knowledge had a human dimension. It was a human product, a human story, the story of an individual aspiring to the universal."

AGAM IN JAPAN

The exhibition "Agam: Father of Contemporary Kinetic Art," held in museums in Tokyo, Osaka, and Kawasaki in 1989, was the first retrospective of Agam's art to be held in Japan. It acquainted people with kinetic art, for until Agam's exhibit, this genre had not been introduced on a wide-scale in Japan. The author organized this exhibition while working in the Cultural Project Department of the Asahi Newspaper which sponsored the exhibition.

Represented in the exhibition were works from Agam's entire career, with some of his earliest pieces from 1952 to his latest creations. Examples of different periods and media were included. Given that there had already been major retrospectives of Agam's work (at the Museé National d'Art Moderne in Paris in 1972, and at the Guggenheim Museum in New York in 1980), the focus in the Japanese exhibition was on work produced since these earlier exhibitions.

One of the pieces on display was a computer-controlled art work in which thousands of images were displayed within twenty minutes. The sixteen screens were orchestrated in such a way as to show one, single, gradually evolving image, or sixteen different ones. This was an appropriate work for a retrospective exhibition, for, in watching the succession of images, the evolution of Agam's artistic research over three decades could be glimpsed to some extent. What was interesting about this particular work was that, while a technological breakthrough had obviously allowed Agam to

synthesize previous approaches, this new aesthetic signalled a certain *dematerialization* of the object.

Agam's works which made use of high-technology were of special interest in Japan. The artist has been something of a

Agam was awarded the Jan Amos Comenius Medal of 1996 from UNESCO.

pioneer in the field of computer art. Already in 1966, when Agam was a guest lecturer at Harvard University's Carpenter Center, he was offering courses in "Advanced Exploration in Visual Communication" in which computer and computer-animated work were discussed. In 1989 Agam's computer art work "Visual Music Orchestration" received the grand prize at the first ARTECH International Biennale (dedicated to art and technology) held in Nagoya, Japan. (The prize was given personally by the Imperial Prince Tomohito of Mikasa, the eldest son of Prince Takahito of Mikasa mentioned below, who was honorary chairman of the Biennale.)

Agam's work, with its combination of art and technology, was, and continues to be, received enthusiastically in Japan. The Japanese live in a society which is constantly creating and developing new technologies. While in France, for example, there is fear that robots will lead to the alienation of humans, the Japanese seek to "humanize" high-tech products so as to enable friendly co-existence. Their private lives are governed by long and strong traditions, yet they work professionally with the latest technology. These realities, however, are seldom linked. Agam works to make such links: Kinetic art works as a "cushion," a base for reconciliation, between man and technology.

When the author curated a retrospective of Agam in Japan, she had fears that the show would not be a large success, kinetic art never having been introduced on a grand scale

*Imperial Prince Takahito of Mikasa visiting the exhibition
"Agam: Father of the Kinetic Art" at the Isetan Museum, Tokyo (1989)*

before. The exhibition, however, brought in thousands of
people each day. Imperial Prince Takahito of Mikasa, younger
brother of the late Emperor Hirohito, visited the exhibition,
and, being a scholar of the history and archeology of the Orient
(he was a lecturer at Tokyo Women's Christian University and
the founding President of the Society for Near Eastern Studies
in Japan), he was able to "discover" the word *shalom* in Hebrew
letters in the abstract work "Peace" (a model of the
polymorphic murals installed in the European Parliament),
which was a pleasant surprise for the artist. It gave the author
enormous pleasure to watch the reaction of visitors: though

usually restrained, they were moving and even "dancing" in front of the polymorph paintings, in order to find the different angles. When strangers would begin talking to each other about the different images within the painting (it rarely happens that strangers in Japan will talk to one another since Japanese people are taught from childhood not to do so), the author could not believe her eyes at this flexible communication. The author was reminded of the Biblical phrase: "Every being participates in the act of creation."

AGAM AND SCIENCE

The author would now like to discuss the affinity between the concept of Agam's art and modern science. There has always been a relationship between art and science. We are no longer surprised to find something in common in the underlying concepts of art and contemporaneous scientific discoveries.

In kinetic art, such relationship is more critically expressed than in other schools of contemporary art such as static paintings and sculptures. The concepts of Agam's art parallel the concepts of science today which deals with reality. Important fundamentals in modern science and modern reality are expressed in a way nobody had used in the field of art.

For instance, as Agam's art can be perceived only in stages and only partially at one given time and does not reveal the whole picture (thus we need "time" to see it), we may be reminded of Werner Heisenberg's indeterminacy principle. The German physicist (in the field of quantum mechanics) came up with the following theory: If you want to measure the exact position of the particle, you cannot measure the amount of movement. It is impossible to measure the mass of a particle at the same time as you measure its speed. That is, if you measure the speed, you cannot measure its weight. One can never have a total view of its reality. It can be known only in parts. This view is reflected in almost all Agam's works. He fused the theory with the ancient Hebrew idea of one God Who is invisible, omnipresent and omnipotent.

Agam was also influenced by Einstein's quantum theory. Prior to Einstein, light was the *phenomenon* but not the *substance*. However, he thought that a light beam which oscillates is a group of *particles* which have energy. (We call this particle a photon.) In other words, he gave substance to the quantic nature of energy. It was actually the realization of Max Planck's quantic theory.

Einstein also argues that in physics there is not one physics alone in everything. Every small unit has its inter-relationship. (For instance, pertaining to the Sun and the Earth, should the Earth come too close to the Sun, it would burn; should it stray

too far, it would freeze. So there is a relationship that keeps everything together.)

In the case of Agam's "Interspaceograph," consisting of many elements, each one is a painting by itself but it is related to another painting (element) and to another..., and as a whole they make one painting. Here, every element is an individual unity by itself, but when combined together with another element and another, it creates another unity. Each has its own unity, is independent and organized, but at the same time, each one is related to another unity, and altogether they make a larger unity.

In the universe there are four forces which govern the energy of the universe. Gravity which holds the universe together, electro-magnetism which is a tremendous energy that pushes light with high speed, the atom, and the *weak particles* which are the force that combines everything. Einstein believed that there must be a *formula* which holds these four forces. They become, as a matter of fact, one force all related in one, in such an organization that each is not the same any more as it was when it existed independently. They are all inter-related, as a unity of the universe. Einstein looked for this force for a long time, but could not find it in his lifetime.

We now know that in a group of fixed stars (such as the Sun) there are some *neutron stars*, and the distance between the atomic nucleus (which is far in the ordinary substance)

becomes almost nil in the neutron stars, and its whole existence becomes *one huge atomic nucleus*. This is a star of high density. There, in high heat and high energy, the forces are inter-related.

In Agam's work titled "New Year," different themes coexist and develop in one painting. You see, on one side, streams of light running, which could remind us of the rainbow (which is nothing but light) and the electro-magnetic; the lines which carry the energy. Another theme which is like exact force (like gravity) which holds the construction of the painting. Yet another theme like atom – a big force (strong theme) which explodes. And then there is the weak force, such as rhythm, which all the time combines all the themes and goes together (It works as a certain force in the painting: not exactly a strong one because there it exists only as a background, but still it holds all the themes together in a rhythm). So, there is a combination of all those things which gives you an impact different from a conventional work of art.

FESTIVE HOURS

The concept of time is a complex one. Many people, however, live and die without giving it much thought. Indeed, entire civilizations and cultures have aspired to overcome the

passage of time, rather than seeking to integrate it into their lives.

When people lead lives which lack change and festivity, reality loses its excitement. One way in which people mark the passage of time, and add color and dynamism to life is through festivals. The Japanese, for example, have various events and festivals which divide the years and seasons, revitalizing time and life itself, and enabling people to attach significance to events in the life cycle. Some festivals occur each month, others only once in sixty years.

The life of the Jewish people is also full of festivities. Each week, from sunset on Friday till the first stars appear in the sky the following day, the Shabbat (Sabbath) is celebrated. To observe the rules and obligations of this day is one of the most basic *mitzvot* (obligations) of the Jewish people. (There were times when Jews were persecuted and even killed by foreign rulers because they stubbornly kept this holy day.) The Shabbat is symbolically called "a queen" (*Shabbat HaMalkah*) – she is an honored guest people welcome into their homes. The Jewish year is full of festivals: starting with Rosh Hashana (New Year), then Sukkot (which commemorates Israel's wandering in the desert during the Exodus), Pesach (Passover), and Shavuot (the day on which the Torah was given on Mount Sinai), etc. On such days, the family gathers to pray and eat together.

"Evolution" (1994)
Two polymorph paintings (above) look different from the front,
while they surprisingly look the same from left and right (below).

This sense of festivity is found not only in life and on calendars, it exists in terms of art. For art is also an approach to reality. Agam places great importance on the active participation of viewers, since he believes that we, in modern times, live in a culture of participation, where one can join in and make choices. The author would like to bring up the idea

"Homage à Pyramid," a soap bubble fountain sculpture which produces bubbles within bubbles

of "repetition" again; does it falsify life? In fact, there exists no single, living creature on Earth that is a "repetition," a copy of some other creature. Even if something or someone appears to repeat the same cycle, nothing is ever a perfect repetition. In just the same way, time never repeats itself either.

Agam puts the question in this way: "Since a man cannot live himself as he was yesterday, he cannot falsify the element of time." Therefore, he is constantly exposed to selections and choices, of how to spend his time, of what to participate in,

and so forth. The value of a man is to be assessed, in the long run, by the quality of the time he has spent.

"The ultimate purpose of the Jews is to live facing the sacred moments of time," Rabbi Marvin Tokayer has said. When someone sees Agam's works, such as "Transparent Rhythm II," "Festivity," or "Dream of Jacob," this quotation by Rabbi Tokayer comes to mind. The viewer can feel the existence of a festive space of marvel, where special, sacred time streams along.

Just as the controlled life of modern man, which consists of the repetition of the same events every week and every month, is a life without the mystery of lively energy, so too do fixed, static paintings, by trying to fix the meaning of life on canvas, shut out all the wonders, beauties, and possibilities of life. Agam, in contrast, always tries to find beauty in the midst of change and the unexpected. He seems proud of making a breakthrough, in finding beauty in the changing process of life, through the medium of artistic expression. When we hear Agam saying enthusiastically "Don't fear change, but enjoy change and love it!" we cannot ignore the Jewish values that lie behind his command, whether he sees it or not.

For a mortal creature on Earth, it is necessary to be renewed and regenerated. A human being needs to "face the time" sometime. Agam explains: "For example, why do people spend

money to see bullfights, baseball, football, or to go to the theater? I think it is to see something that time creates." He continues, "Either roulette, or slot machines, or whatever, almost all gamblers enjoy the 'unexpectability,' where man has a tête-à-tête with 'time,' and confronts 'time.' Then, and only then, can man feel a moment of liberation from the all-controlled and organized life that he usually leads."

In fact, even holidays, which were originally created to add a rhythm of change to life, have already become a part of the organized cycle of life. Life thus lacks any "magic." However, because of that situation, man yearns to get away from the mediocre repetition, and the resulting ennui, of his life and tries

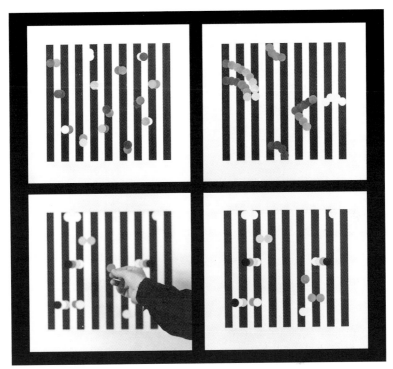

Transformable "Dialogue" (1975)

to escape it by "facing time." Perhaps this is one of the basic instincts of self- preservation that he has as a living creature.

In short, then, Agam *intentionally* introduced into art such questions as "what can a living creature create in time? What kind of wonder and marvel can he create in the time which he has for life?" Thus by using the terms of art, man can have the

◄ *Kinetic sculpture "Kahala Welcome" (1987) animated by a group of dancers*

pleasure of creating and destroying forms, "in the painting" and "with the painting." Through such participation, the viewer realizes his own creativity, step by step, and is motivated to develop that talent further – from a low level of creativity to a higher level of creativity. Agam's many works, in varied genres of plastic creation (and even in education), which use a multitude of materials and techniques, all lead to this development of creativity.

Furthermore, man as *homo ludens*, by playing, inevitably and naturally becomes aware of the many aspects of this process. He starts to consider widening his "vocabulary" of

"Gesticulating Sonorous Sculpture" (1973), an invisible work: Each of the viewers' movements in front of the work creates a corresponding sound. (Agam's one-man exhibition at the Cultural Center, Bourges)

expression – from the second and the third toward the fourth dimension. In other words, a man searches for both the theory and aesthetics of forms in the fourth dimension, and searches for how to create a form which is more creative and expressive in the realm of the fourth dimension.

FOUNTAIN "SHAMAYIM"

Agam often surprises with the materials he uses in his art. When he first visited Japan, he came to the office of the Asahi Newspaper to be interviewed, and showed me a video of the "Fire-Water Fountain" installed at Dizengoff Square in Tel Aviv. It consists of a huge sculpture (3.4 meters high, 6.3 meters in diameter, and 5 tons in weight) placed in a reflecting pool of water (12 meters in diameter). A computer activates the fountain by synchronizing the rotation of the wheels (covered with polymorphic painting which changes colors) and the movement of fire and water with music. At particular moments (in tune with the music) fire spurts forth from amidst the water. As Agam began to talk about his work, the word "magician" popped into my head – a magician with a long white beard, dressed in black, and wearing a rabbinical hat.

In Hebrew, water is "mayim," and fire is "esh." Those two elements are really opposites; they essentially contradict each other. Using a particular technique, Agam achieved the

coexistence of fire and water. He explains "fire and water," "esh-ve-mayim" in Hebrew, if shortened, is eshamayim. Fire and water are two opposing substances that are united in Hebrew in one word – and one meaning – "Shamayim," "Heaven." Agam says that if you understand Hebrew, you can *understand visually* the message of this sculpture in a moment, seeing the fire erupting from the midst of a wave of water.

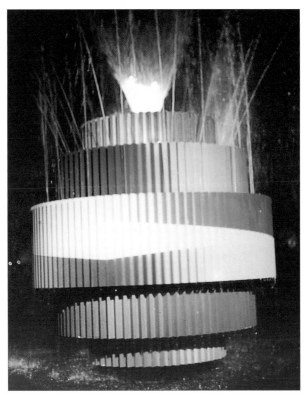

Fire and Water Fountain "Shamayim"
in front of the Tampa Convention Center (1991)

While the rainbow colors of the sculpture change from moment to moment, creating an infinite number of variations, fire and water combined keep on sending the visual message "Heaven." This piece thus created a festive space, becoming one of the focal points of the city center. Some argued about whether it was art or not, but I would prefer to think that it is a visual fantasy, meant to create a festive time and space. (While looking at this piece, the fanciful thought came to mind that the inspiration of many Jewish movie directors who produced fantastic movies may derive from having the Bible in their background, whether they are aware of it or not.)

In order to express a non-static reality, Agam deliberately chose the seemingly contradictory materials of erupting fire and running water, which can never be fixed and therefore represent the stream of life itself; "Instead of using fixed materials such as stone, steel, or marble, I chose materials of flux, whose nature is to change. I chose materials which had never before been combined," explains Agam. Constantly moving and changing, there are infinite variations of the fountain's appearance. Fire and water and the visual message of "Heaven" which they knit together at every moment present the enthusiastic message of an artist who wishes to make viewers feel the *reality of life*. Here again, there is a quintessentially Jewish aspect to the fountain in that it is "constantly becoming" rather than static in existence. The

piece is something of a visual fantasy which produces a festive space and time.

AGAM AND MUSIC

While working on the Agam exhibition project to be held at various Japanese museums, I visited Agam's studio in rue Boulard, near Montparnasse in Paris. There he showed me an unusual record player. "What is this?" I asked. "What is its name?"

The record player had four arms and was still able to function. Agam offered to play a piece of music that he had composed in 1962, entitled "Trans-formes Musicales." He placed all four arms on the record simultaneously, and what emerged was what one could call "multi-dimensional, polyphonic music." On the record were engraved several musical sequences played by different instruments (such as piano, violin, percussion, and so on). The listener chooses and *recreates* the music, like a composer or a conductor, by putting the arms in different places on the disk. How many arms you put on the record, all four, or just two or three, at once or successively, is all up to you as well. The result is a fusion of different sounds which together form a new symphony. Each creation is utterly original; "You can never play exactly the

same music a second time, *never*," said Agam with a smile. It
is irreversible, therefore, every time it is original.

When one looks at a painting, all the information already
exists there (whether one discovers it or not). With music,
however, it is impossible to listen to all the sounds at one time.
The passage of time is needed to grasp the whole work. There

Record player with four arms, with Agam's
original music "Trans-formes Musicales" (1962)

is, however, an aspect of music that bothers Agam: music is played in the same way time and time again. There is no change, no "becoming," no real exploration of time. Of course, creative conductors may interpret music in a particular way, and emphasize different aspects of the piece; or musicians may play polyphonic music, such as J.S. Bach's, in which there is space for them to improvise and arrange the music (this space is called the cadenza). But, although there are some possibilities for reviving music, most musicians do not take these opportunities. "Instead of improvising as the composer originally wished, musicians merely combine different fragments of set music to fill in the space, simply making a *montage*. People lack the creative capacity to make the music come alive, or is it merely a result of laziness?" asks Agam. It is part of human nature always to choose the easier way like this. Therefore in musical performances, strictly speaking, there is usually *continuity*, but not the *element of time*, in the sense that the inclusion of the element of time should create something unexpected and unpredictable. When someone plays the same piece in the same way, over and over, it becomes a mere copy and loses the creative excitement in the music, for both the audience and the performers.

Agam therefore set about exploring the notion of transformable music. "You know, my first artistic research was done in the field of transformable music. This is a piece of music that, once played, can never again be played in the same way,"

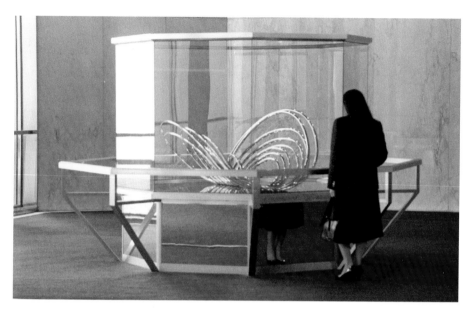

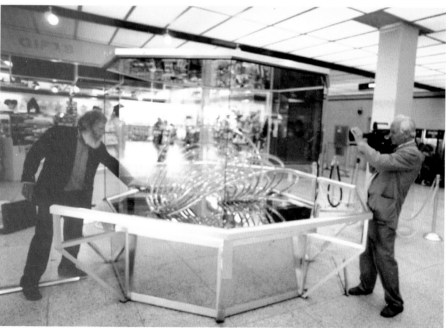

Top: "Wings of the Heart," movable and transformable sculpture, at the World Trade Center, New York, exhibited before being installed at the John F. Kennedy Airport, New York (1988). With this artwork, Agam won the international competition organized by Air France to celebrate the 200th anniversary of the Statue of Liberty.
Bottom: Film maker François Rauchenberg shooting "Wings of the Heart" at John F. Kennedy Airport, New York

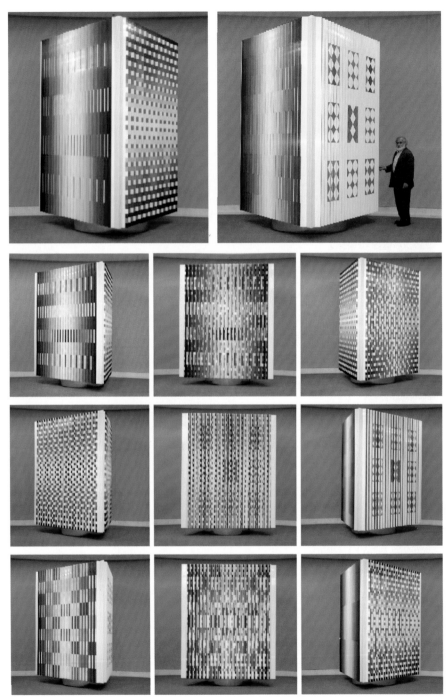

"Welcome," revolving three-sided polymorph, eleven different views, Mayo Clinic, Rochester, Minnesota (1975–82)

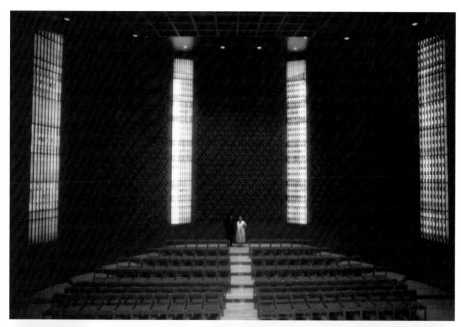

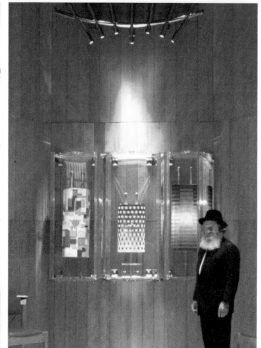

"The Twelve Tribes," 27-foot-high-polymorph stained glass windows, Torah Ark, eternal light and Torah cover of the synagogue of the Hebrew Union College, New York (1980)

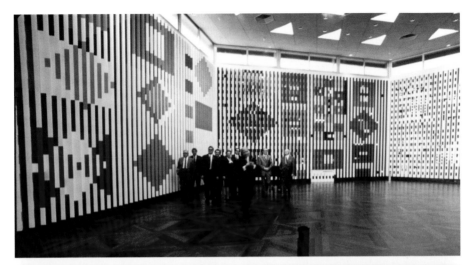

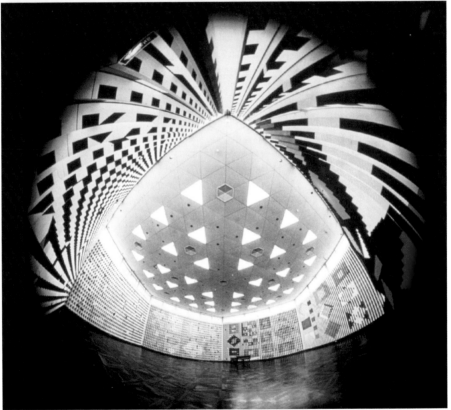

Top: "Agam Space," Forum, Leverkusen, Germany (1979)
Bottom: Fish-eye view with a concert piano in the center

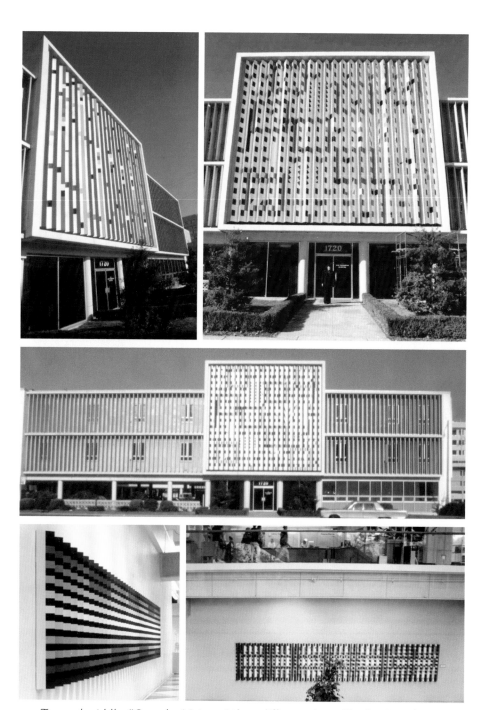

Top and middle: "Complex Visions," three different views, The Eye Foundation Hospital, Birmingham, Alabama (1970).
Bottom: "Visual Reading," two different views, Public Library of Fort Lauderdale (1985)

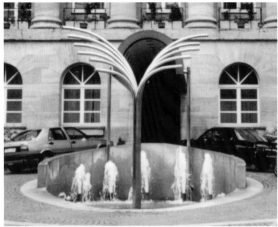
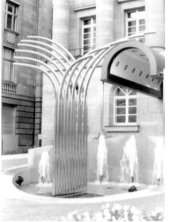

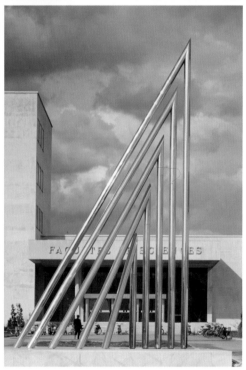

*Top: "Touch Me," transformable sculpture, two different views, West Deutsche Landes
Bank, Frankfurt, Germany (1970)
"Eighteen Levels" (middle left) and "Super Line Volume" (bottom left), transformable
sculptures, at the exhibition "L'art en mouvement" at the Fondation Maeght,
Saint-Paul, France (1992)
Bottom right: "Tents," transformable sculpture, University of Dijon, France (1975)*

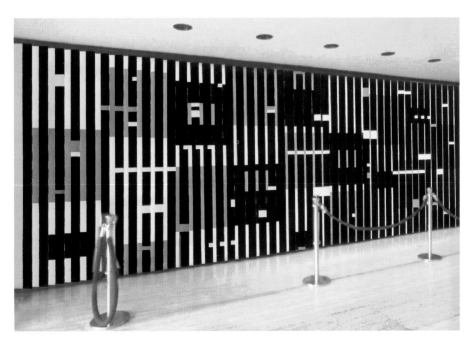

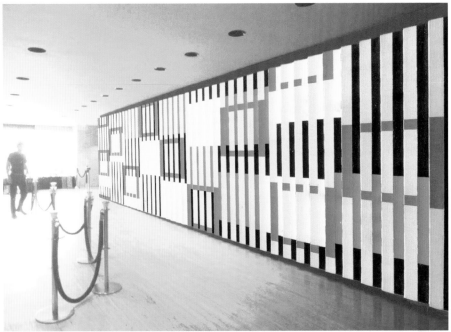

"Communication, 'Night' and 'Day,'" two different murals: "Night" (top) and "Day" (bottom), AT&T Building, New York (1974)

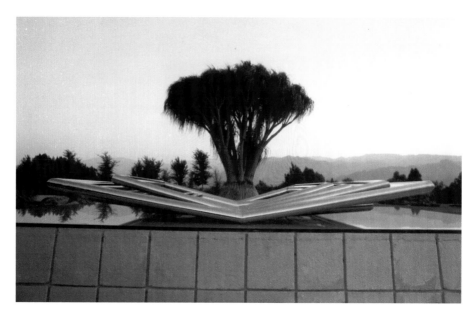

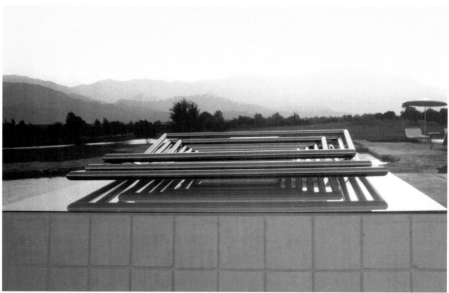

"Square Waves," movable sculpture, two different views, Annenberg Estate, Rancho Mirage, Palm Springs (1976). This is an expression of perpetual movement and balance, forever moving at the slightest touch of the wind

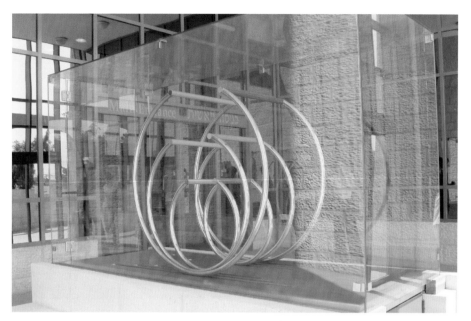

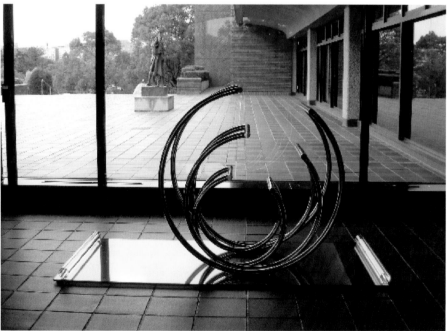

Top: "Cosmic Movement," a colored sculpture animated by a hidden magnetic impulser controlled by the computer, Yad Sarah Building, Jerusalem (2002)
Bottom: Manually operated version, "Movement × 3 Synchrone," Fukuoka Art Museum, Japan (2002)

Top and middle: Models for the 3D Center, Prague (2003)
Bottom: Agam in his studio working on the 900 color samples that
will bring life to this originally dark and gloomy building of the communist era

3D Center, Prague (2005)
Top: The 900 different colors viewed from the front vanish from the side view leaving
but a majestic rainbow on at the top of the building

Neeman Towers on the seashore of north Tel Aviv (2002)

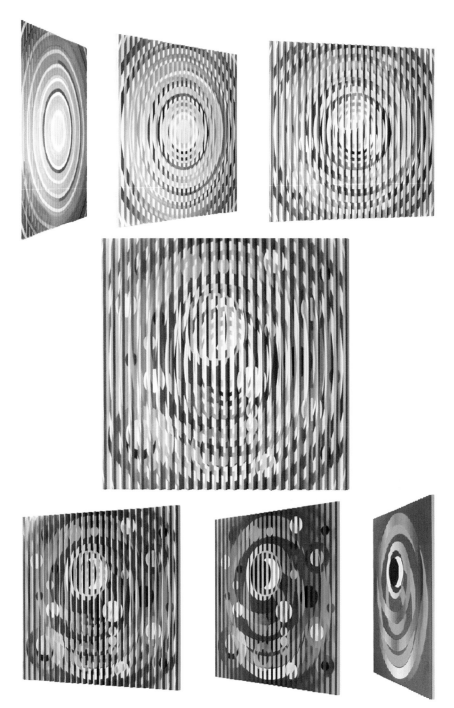

"Sun and Moon," seven different views, collection of Eli and Anita Jacob, U.S.A. (2005)
Size: 42.5"×42.5" (108 cm × 108 cm)

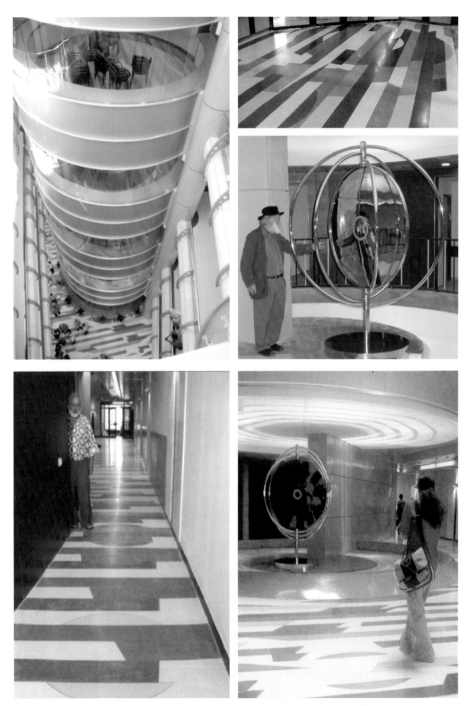

Terrazo floors of the Brain Study Center, Bar-Ilan University, Tel Aviv (2004)
Middle and bottom right: "Cosmic Reflection," movable sculpture at the entrance

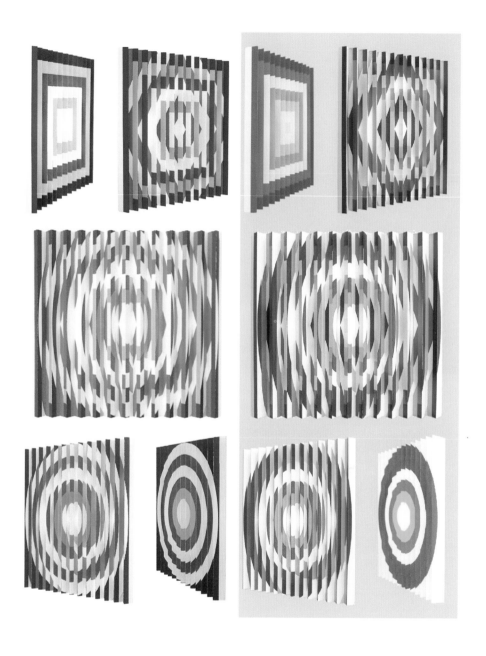

"Quadrature du cercle," five views of two different paintings (right and left) as a visual orchestration of the same theme (2006)

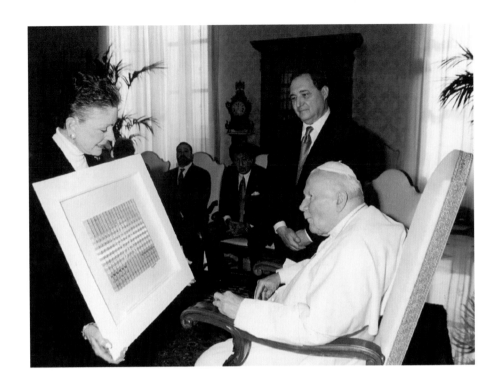

Top: "Visual Prayer for Mutual Hope" (2004) bestowed as a gift to Pope John Paul II by the Anti-Defamation League
Bottom: Three different views of the painting, representing the Star of David, the Star of Islam, and the Christian Cross in harmony on a rainbow background

explains Agam. "There is no 'correct' way of playing such music. Each musician, based on his or her ability, creativity, and musical sensitivity, simply chooses one or even several parts out of the score. There is no indication in the score how he or she should play. Therefore, it is totally impossible that the piece should be played exactly the same way."

"Then, it is all up to each player's ability whether he would take it as an advantage to express his musical sensitivity in a creative manner, or take it just as a burden. But, as you can imagine, ability could be developed, too, I believe," said Agam.

"In fact, the music of such structure carries *change* in itself. However, in the field of painting, usually such 'change of structure' has been impossible. I proved in my early (transformable) paintings that, while the complex forms limit the possibility for change (as they are structurally fixed), using the condensed basic forms (which are simple) offers more possibility to make an infinite number of variations and transformations. If you think the same way, the type of music which you can repeat over and over again carries *continuity of time* but does not include the *element of time* in itself. On the other hand, the type of piece which has an allowance (flexibility) for change represents the real notion of *time* and may develop the creative ability of musicians," continued Agam. In this way, Agam introduced the factor of "play" into his work, which functions in a similar way to improvisation in music. For Agam, music and visual art are the two sides of one

coin, as they both allow for the expression and materialization of the element of time, which has always been at the center of his interest and of his varied research: in music, sound, rhythm, and pitch change with time; in Agam's art, color, form, and rhythm are transformed over time. Agam's art is indeed a form of visual music.

"By the way," says Agam, smiling. "I once wanted to become a musician (and still see myself as one)." This was a surprising confession coming from a painter/sculptor! "When I was in my twenties, after much rehearsal, my piece was finally to be performed in a public concert. The conductor, however, never appeared! At the last minute he had decided to conduct a Beethoven concert instead. Of course, Beethoven's piece is much more famous than mine, and he was to be paid more for his work," said Agam laughing. (I later discovered that the said conductor was Gary Bertini, who is known as one of the best conductors of Gustav Mahler's works.) "This experience made me realize that in a musical career, one is inevitably dependent upon others – musicians, conductors, and so on. Without them, my piece could not be performed. I wanted to be independent of others and to continue my own research." Agam thus became an artist of visual music.

From this episode we understand the very important fact that the resemblance of Agam's art to music (which includes the factor of time) is very natural for him. In fact, when Agam talks about the element of time in music, it is a better

explanation of his work than any critical theories of art. He explains, for instance, that "in a conventional piece of music, even a small change can break the whole structure of the piece, because it is made so static, so rigid, not allowing even a little bit of change." One might well recall paintings by Mondrian such as "Horizontal – Vertical" in which just the slightest change (of a point or in the slight elimination of a line) would destroy the balance of the whole structure of the work, and change it completely.

When we look at Agam's major works, we can notice that many of them have titles related to music. These include his early masterpiece "Melody" or "Orchestration – Counterpoint," "Staccato," "Rhythm and Color," and "Homage to J.S. Bach," as well as his more recent computer art work "Visual Music Orchestration," which shows many thousands of different images in just twenty minutes. It seems clear that we cannot understand, or enjoy to the fullest, Agam's paintings and sculptures in movement if we do not follow its dynamic process as one would when enjoying music.

"AND GOD SAW THAT IT WAS GOOD"

In the Judaic tradition, knowledge tends to be based on intuition and spiritual sense rather than on *logos*, a Greek contribution to intellectual processes. When knowledge is

more than merely information, but rather a type of wisdom which carries creativity in some sense, then we see that it can sometimes be acquired from strange experiences, such as dreams and sudden revelations. Agam is a man of intuition. The unexpected quality of beauty, and the poetry of the combination of colors in his works do not originate in study or formal training.

"Have you ever wondered why it is written in the Bible the 'God of Abraham, God of Isaac, God of Jacob' rather than the 'God of Abraham, Isaac, and Jacob'?" asks Agam – an unexpected question. "It is because God revealed Himself differently to Abraham, Isaac and Jacob. God took on myriad forms because each of these figures was an individual, with different ways of thinking and different ways of responding to experiences. Abraham, Isaac, and Jacob each faced God alone, and in his original and unique way, and the God they confronted altered slightly in each case."

Agam points out that none of these Biblical figures had been prepared or expecting to receive revelations from God. It just happened. Just as dreams come unexpectedly. Agam believes that it is the right side of the brain which responds to phenomena such as dreams and revelations. If this is so, then the capacities for insight, creativity, and intuitive thought can be trained and developed.

Agam suggests that the way to develop these qualities is through sight. "For instance, in the Book of Genesis, at the end of the day's work of the world's creation, it is written, 'And He saw that it was good.' Why did God Who must be Almighty, Who is all-knowing, have to 'see' His work?" asks Agam. He continues: "I think God had to see in order to judge whether or not His work was good. For, to see is to know. Sight and knowledge are linked. If sight is necessary even for Almighty God to know, how much more so is it necessary for us mortal humans!"

In the Book of Exodus in the Bible, it is written that when the people of Israel received the Ten Commandments at the foot of the Mount Sinai, they "saw the sound." This passage of "seeing the sound" is intriguing, and I asked Agam what he thought of it. He replied: "Through seeing the sound, people came to *know* the reality of God. To see sound is to grasp its essence." His point of view in interpreting the Bible, based on his intuition as an artist, seems inspiring to me. Suddenly the stories of the Old Testament, which seemed to me the myth and tradition of the faraway past, became vivid, real, and modern.

Agam believes that most mature people in modern times are "visually illiterate." Their visual ability is already so downgraded that, while they can name objects and different forms, they cannot actually "see" them. Non-static art,

however, could enable people (even those who unconsciously refuse to see the forms) to "see" when they get familiar with it (non-static art) and actively and creatively participate in it. By approaching the *reality*, which is in the process of "constant becoming and transformation," with the help of the *language of form*, they can acquire the *ability to see* – which can be regarded as the language of the Almighty – and understand what the "act of seeing" truly means. Agam thinks that this attitude toward visual perception is the essence of the Second Commandment, "You shall not make for yourself a graven image." For even Almighty God judged His work by "seeing" that "it was good."

For a long time, this commandment functioned to prohibit Jews from working in the area of plastic art. It is, after all, a powerful commandment, explains Agam, coming second in the list of Ten Commandments, much before the prohibitions against killing, stealing, adultery (Sixth, Eight and Seventh Commandments), etc., and in fact being the first which actually instructs (since the first of the ten is a statement rather than a command). As a result, Jews traditionally turned to music rather than visual art to express their creativity. Only in the last hundred years or so, with the liberalization of Jewish society, have Jewish artists begun to emerge, such as Amadeo Modigliani, Chaim Soutin, and later Marc Chagall and Ben Shahn. Agam, as a young artist-to-be raised in a very religious home, also struggled with the contradiction between the

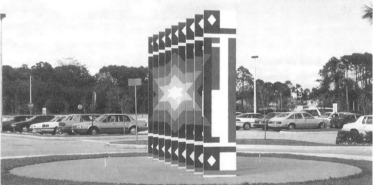

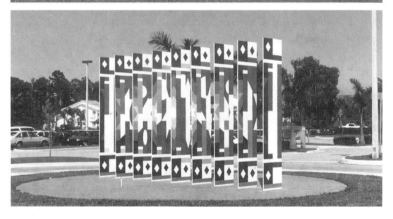

"Jewish Welcome" (1993) at the Jewish Community Center of
Greater Palm Beach (three views)

forbidden "graven images" and his intense urge to create. He tried hard to find a new form of art that would not desecrate the Second Commandment.

Instead of taking the prohibition against the graven image as an obstacle, Agam rather put forward his own unique *interpretation* of the Second Commandment: It was a huge step forward in the creation of a *quintessential Jewish art form*. What Agam came up with was abstract, non-static art which exists in a flexible *situation*, encouraging the viewer to participate in the creative process of his changing art works. He creates dynamic rather than graven images. Agam seeks to improve the visual understanding of people to help them acquire "visual language" by grasping the essence of the act of *seeing* (or, visual reading), so as to enhance their creative abilities and to encourage people to lead lives which give proof to their having been created in the "likeness of God, the *Creator*." In these aspirations, the enthusiastic message of Agam the visual rabbi can be heard.

Agam's work presents us with the Jewish view of reality as described in the Kabbalah (the book of Jewish mysticism): "the realization of His existence, Who has no form and has no name." As God's name, and His reality which is hidden from our eyes, are neither finite nor definite, why then must man's creativity, given by God, be limited or static? Transformable art mirrors unlimited, dynamic reality. Agam's art changes constantly, just as day-to-day reality which changes moment

to moment, revealing itself differently to each man and woman, enabling them to have a glimpse of the world of the hidden and to touch the wonders of life, the real sense of *L'chaim*. Agam's unique form of expression (which is in a state of constant becoming) reflects *reality according to Judaism* as something singular, and different from art rooted in other cultures.

Top: Agam with Jerusalem Mayor Uri Lupolianski
holding a model of "Touch Me" sculpture
Bottom: Agam with former Jerusalem Mayor Teddy Kollek
with multigraph on the theme of old and new Jerusalem

SUNSET IN JERUSALEM

It was during the New Year holiday of 1983-1984 that I first saw Agam's work in Jerusalem. I was working at the time in the Asahi Newspaper's Cultural Project Department and was thinking of organizing an exhibition in Japan of the Dead Sea Scrolls. The discovery of these scrolls in Quilvet Qumran, near the Dead Sea, was one of the most significant archeological events of this century, and their existence and contents eventually rewrote the history of Christianity. Another purpose of my trip to Israel was to grasp the reality of Israel with my own eyes, to fill in the gaps between the actual Israel and the image of war and peace that is projected in newspaper headlines. I wanted to see what the real Israel is, compared with what I had read in books. I wrote several serial essays for a magazine after I returned from my trip.

The Dead Sea Scrolls are housed in a special building at the Israel Museum, called the Shrine of the Book. This is an unusual building, shaped to resemble the top of the clay vessels in

which the ancient texts were discovered. If one did not know it was a building, one could easily think it was a huge, outdoor sculpture. On the path leading to this building stands Agam's transformable sculpture, "Eighteen Levels." It was strangely natural to see the unusually shaped building and sculpture sharing the same visual space: one enshrined sacred texts which had been hidden from the world for nearly 2,000 years in a time-capsule; the other, although intensely contemporary and utterly free of any decoration, drew only from the essence and the spirituality of Judaism and crystallized it in plastic form. Indeed, for the Jewish people, history is never complete but is flowing continuously inside its body, like blood. For them, the Promised Land was always a reality, even when it existed only in the depths of their hearts. Events of two thousand years ago have the same impact and relevance as events of fifty, forty, even several years ago. This people has been called the nation of remembrance; it never forgets. The hope (*Hatikva* in Hebrew – also the name of Israel's national anthem) to return to the Promised Land of the forefathers has kept the people alive during two thousand years in the Diaspora, even during the worst eras of the pogroms (persecutions of the Jews) and the Holocaust. Each year, at the end of the Passover *Seder*, Jews express the wish: "Next year in Jerusalem."

Since Agam began and established his artistic career in Paris, the French recognize him as one of their own, just as that country of culture and art had adopted Picasso from Spain, Ernst from Germany, Calder from the United States, Soto from Venezuela, Tinguely from Switzerland, and so on. Agam can also be positioned as an artist working on the international stage. Nevertheless, when I heard that no matter where in the world he happens to be, Agam tries to return to Israel for the Jewish High Holy days, I see in this, not only as a Jew living in the Diaspora trying not to lose his ties with the Jewish state, but also as a Jew facing God alone, he tries to link himself to Jewish history and traditions, like an infant holding desperately onto the umbilical cord.

When I think of Agam in this way, I am reminded of the story of Marc Chagall. When Chagall was asked to create a series of stained-glass windows for the synagogue at Hadassah Hospital, Jerusalem, he abandoned all his other work in order to undertake this project. (It was actually in the 1950s, when the memory of the Holocaust was still so fresh.) As he was absorbed in this work, he felt on his shoulders the eyes of his mother and father, and behind them, the millions of Jews who died yesterday...and several thousand years ago.

Agam's profound and important ideas about art are directly inspired by ancient Hebrew concepts of reality. He attempts to give plastic and artistic expression to these concepts. In doing so, Agam turns the religious prohibition against making

"graven images" to positive advantage: it was this which led him to create visions which metamorphose and transform constantly, and overturn the accepted notion of art as a fixed, static image.

"The image in my art exists as a possibility in the midst of its becoming, rather than a static, petrified look of reality," wrote Agam in his *Artist's Credo*. Only such *unstatic* art is capable of reflecting unlimited, dynamic reality. Agam continues: "My intention was to create a work of art which would transcend the visible, which cannot be perceived except in stages..." What is depicted in Agam's art, therefore, is a *partial revelation* of a unified whole and of a constantly evolving reality.

"My aim is to show what can be seen within the limits of possibility which exists in the midst of coming into being." To this aim, Agam has always been faithful.

Sayako Aragaki

Sayako Aragaki was born in 1957 in Chigasaki City in Kanagawa, Japan, the daughter of Hideo Aragaki, a famous columnist and author.

Ms. Aragaki graduated from Keio University.

While working for Japan's leading newspaper, *Asahi Shimbun*, from 1982 to 1989, organizing museum exhibitions, symposia, lectures, etc., she had an opportunity to curate a retrospective exhibition of Agam in 1989.

Since 1990 she has been freelance writing for newspapers and magazines in Japan, the United States, France and Latin America, as well as writing and editing exhibition catalogs for museum shows.

In Japanese, Ms. Aragaki published *Agam and Jewish Art* (Tokyo: Lithon, 1993).

She also translated from English into Japanese *Agam* by Frank Popper (New York: Harry N. Abrams, 1990) and *A Woman on Paper: Georgia O'Keefe* by Anita Politzer (Tokyo: Shobunsha, 1992).

The author is a member of the Japan PEN Club and the Japan Travel Writer's Organization.